The Journey of

"A Good Type"

H15004

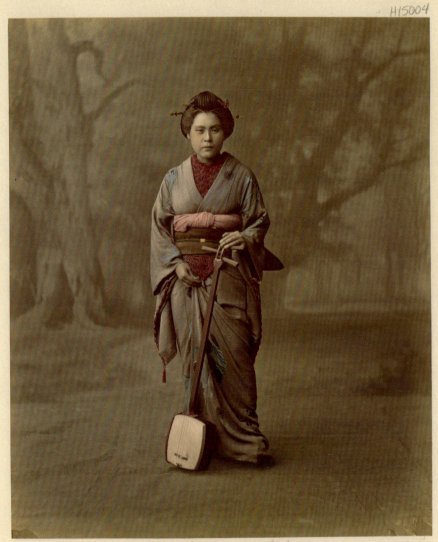

Shows very well how a Japanese woman's
dress looks when ~~~~~~~~ properly put on 663

(a good type.)

The Journey of

"A Good Type"

From Artistry to Ethnography in Early Japanese Photographs

David Odo

Foreword by Elizabeth Edwards

Peabody Museum Press, Harvard University
Cambridge, Massachusetts

Peabody Museum Press
11 Divinity Avenue, Cambridge, Massachusetts 02138
Copyright © 2015 by the President and Fellows of Harvard College
All rights reserved. Published 2015.
Unless otherwise noted, all photographs and illustrations are courtesy of the Peabody Museum
of Archaeology and Ethnology, Harvard University. Photographs on pp. 58 (left), 82, and 85 are
copyright © the President and Fellows of Harvard College.
Printed in Canada

ISBN 978-0-87365-408-1

Library of Congress Cataloging-in-Publication Data:
Odo, David.
The journey of "a good type" : from artistry to ethnography in early
Japanese photographs / David Odo ; foreword by Elizabeth Edwards.
pages cm
Includes bibliographical references and index.
ISBN 978-0-87365-408-1 (cloth : alk. paper)
1. Photography—Japan—19th century—History. 2. Japan—History—19th
century—Pictorial works. 3. Japan—History—19th century. 4. Visual
anthropology—Japan—19th century. 5. Peabody Museum of Archaeology and
Ethnology—Photograph collections. I. Peabody Museum of Archaeology and
Ethnology. II. Title.
TR105.O34 2015
770.952—dc23 2014044372

∞ This paper meets the requirements of ANSI/NISO Z39.48-1992 (Permanence of Paper).

Frontispiece: *Singing Girl ("A good type")*, 1870s. Studio of Stillfried & Andersen Co., Raimund von Stillfried, photographer. Hand-tinted albumen print on paperboard mount. Print: 19.2 × 23.7 cm (7½ × 9¼ in.); mount: 28 × 35.5 cm (11 × 14 in.). Collected by William S. Bigelow, 1880s. Gift of Mary Lothrop, 1927. PM 2003.1.2223.310 (101160028).

CONTENTS

❧

ILLUSTRATIONS

FOREWORD
WHAT PHOTOGRAPHS "DO" IN MUSEUMS
Elizabeth Edwards

Almost all museums have photographs in their collections. Over the years these collections have been generated, acquired, and utilized in a myriad of ways. Some collections are the result of intentional and systematic collection, some are the result of ad hoc enthusiasms, yet others are the result of almost accidental photographic accruals around object collections; often, the process is entirely serendipitous. These accumulations and assemblages of photographs exist for a multitude of reasons and fulfill a multitude of roles: as documents and evidence in their own right; to authorize and authenticate other classes of objects; to manage collections; to act as surrogate collections; to salvage material and cultural subjects thought to be disappearing; as objects of art, science, or technology; or even as a simple source of wonder, delight, or curiosity.[i] The photograph collections at the Peabody Museum at Harvard are all these things. In *The Journey of "A Good Type,"* David Odo has undertaken the brave task of guiding us through this maze by examining the museum's holdings of late nineteenth- and early twentieth-century photographs of Japan, notably those that formed the Bigelow collection, acquired in 1927. While these photographs are amply worthy of attention in their own right, Odo importantly asks what the Japanese photographs tell us more broadly about what photographs "do" in museums.

Writing about collections history and ethnographies of collections and institutional practices is well established, of course. Scholars have looked at topics as diverse as the seventeenth-century *Wunderkammer,* the eighteenth-century passion for the classical, and the colonial collections of the nineteenth and early twentieth centuries. However, the history of photograph collecting and photograph collections has received little attention. Possibly this is because the role of photographs in museums has been seen as something ancillary, of marginal status—and indeed interest—in relation to the "real business" of museums. Photographs are merely information, not "real" collections. Yet we are beginning to

realize that such collections have a lot to tell us about museums, their collections overall, and especially the way museums make knowledge.

To understand the mechanisms of nineteenth- and early twentieth-century photographic collecting in institutions such as the Peabody Museum is to understand a lot more than simply a photographic history.[ii] What *were* the practices of collection, and what were—indeed, are—their consequences? How did they come to be in museums? And what did they do there? How did knowledge about sources of photographs spread? How were the production and the market managed? Exactly how were photographs like many of those discussed in this volume positioned between art, science, and the popular? At what moment did these photographs become "documents"? At the moment of making? At the moment of collection (by Bigelow, for instance)? At the moment of donation to the museum and of archiving in its systems? Or in the acceptance statement in the annual report of the museum's trustees? Arguably, these extremely complex questions make the study of photograph collections especially revealing of larger systems. This complexity echoes Christopher Pinney's question, From which moment can a specific object be said to come?[iii] Conversely, how many kinds of thing can an object be simultaneously: art, science, document?

The answer is that the meanings of both photograph and collection are made through all those different moments of production and use in some way or other, as the photographs become multiply entangled with shifting values. Indeed, another reason why photograph collections have tended to be marginalized within institutions and within the writing of collections history is that they do not always sustain a specific and unchanging notion of relevance or importance over time. Instead, they drop away into yesterday's science. To our contemporary eye, studio portraits of Japanese figures do not measure up as scientific data—but that flux is precisely their interest. The fascinating account here of the division of Bigelow's collection between the Peabody, Harvard University, Museum and the Museum of Fine Arts, Boston, speaks volumes because it tells us exactly how the categories of interest and significance were being made at a certain historical moment.

These questions and some of their answers weave their way through Odo's account. Bigelow's social and academic networks, for example, show the complexity of aesthetic motivation and scientific aspiration. And these motivations and aspirations themselves are informed by the shifting assumptions and values of the world that embeds them, from the microlevels of physical anthropology

to the macrolevels of political, economic, and social change in the United States, Japan, and the wider world.

Odo's approach to collections reflects broader shifts in the disciplines of visual anthropology and of museum and material culture studies and is informed by a growing body of work in which the social practices of photography, archives, and museums have become the focus of ethnographic studies. Ideas of visual economy have also inspired studies that look at how images actually work within visual regimes. Such studies locate the meaning of photographs not only in content and style but also in patterns of consumption, dissemination, ownership, archiving, and reproduction within a complex network. Material culture approaches have brought the idea of the photograph, its formats, and its modes of presentation and preservation—from albums to mount cards to hand-tinted prints—to the fore as active elements in photographic meaning. And for those working on photograph collections, anthropological and ethnographic approaches have fostered a sensitivity to the interconnectedness of photographic practices and the social expectations brought to them.

Thus, the questions we ask of photographs and photography collections have changed. Until recently, the analysis of historical photographs has often focused on their representational strategies alone. How were stereotypes created and maintained, and why? What were the politics of this unequal contract of photographic production in colonial and quasicolonial situations when photographic power was somewhat one-sided? In attempting to answer such questions, we have tended to look at single images and slot them into a particular kind of visual regime that is understood to make certain forms of images thinkable and understandable at a given historical moment. Those older questions don't go away, of course; they remain an important part of the discussion. But differently informed approaches offer new ways of thinking about photograph collections that take us beyond questions of representation alone and look at how photographs work in broader networks and economies of meaning. The museum itself is a node in such networks and economies.

Consequently, we are beginning to see anthropological studies of ethnographic institutions themselves—such as photograph collections—as cultural entities in their own right. Material practices, as I have suggested, become really important, reflecting the influence of reinvigorated and retheorized material culture studies in anthropology over the last couple of decades. In Odo's account, the transformative acts of mounting, storing, labeling, relabeling, cataloguing, and recataloguing become the key practices through which the

Foreword

photographs acquire meaning, the ways in which they become one kind of thing and not another. One of the delights of this volume is how the careful, high-quality reproduction of whole mounts, with their palimpsest of annotations, labels, and markings, enables the reader to actually see these processes in action.

While the Japanese collections are the focus of this book, similarly shaped stories could be told of other parts of the Peabody Museum's photographic collections. One particular point of interest is the preponderance of commercially produced photographs from the late nineteenth century. This has a number of advantages for studies such as this. First, one is looking at separate yet conceptually linked acts of collection covering different parts of the globe, all of which address specific museum interests. Second, the Peabody collection represents a very substantial landscape of the flow of commercially produced photographs that were being absorbed into scientific interests at a given historical moment. Although Bigelow's own collection did not arrive in the museum until 1927, it joined thousands of photographs from, for example, the Alexander Agassiz collection, which had undergone similar physical and intellectual trade routes, from the peripheries of production to the epicenters of metropolitan interpretation, where photographs were pondered over, ascribed new meanings, and turned into new kinds of things: in this case, scientific documents.

But these questions and their answers are of more than local significance. One of the major arguments of this book is the way in which the flow of photographs into different kinds of spaces—art, science, anthropology, museum, tourist album—allows new meaning to be made. This flow is enabled because photography is a reproducible medium. That is its particular contribution to culture, its ability to move the fixed image across space and time.

This lack of uniqueness and the repetition of photographs across different museums has often been held against photographic collections, as if they are "less precious" in a hierarchy of museum values built on concepts of uniqueness. Yet the reproducibility of photographs in this context is the root of their desirability and, for us, their interest as what we might term "multiple originals." Not only did prints made from the same negative allow scholars in different places to use a shared and understood range of images to provide "documents" in their field, but these multiple originals also allow us, as collections historians, to see where the concentrations are, what are the images that all institutions have. What are the clusters of photographs that are deemed important, desirable, and, above all, reliable, as information in a given context? These are the important elements in the making of museum knowledge.

The significance of the Peabody Museum collection lies not in the collective value of single images, but in its uniqueness as a particular configuration of material objects and the particular work these images perform within this museum as an institutional environment. Thus the unique value of the Bigelow collection and other Japanese material discussed here is as a *collection*, an assemblage of photographic objects that relates to the Peabody Museum in very particular ways that are at once profoundly local and profoundly global. They must be understood, too, as a whole collective system that is not simply the sum of individual images, either single documents or singularities stitched together. Rather, it is like an ecosystem—sets of interrelationships, dependencies, practices, materialities, curatorial values, and institutional hierarchies. It is, therefore, integral to and inseparable from the museum's knowledge practices.[iv]

Studies such as David Odo's make clear the extent to which photographs are a crucial part of the museum ecosystem. The analysis of the images—their collection history, their place in the wider visual economy of the networks of knowledge making—stretches not only across Cambridge and Boston but also across the world in a global flow of images and ideas. Overlaps exist not only with other scientific collections, but also with other popular acts of collecting.

Is a photograph, then, a work of art, a souvenir, a document, or a piece of museum discourse? It is, of course, all those things simultaneously. This is the intellectual excitement of working with photographs: It is very easy to say what they are not, but much harder to say for sure what they *are* as they shift through space and time, accruing meanings like a stone gathering moss. At the same time, through their institutional framings, they may divest themselves of meanings: they are stated to be anthropology, not art—or perhaps art, not anthropology.

In his exploration of the Bigelow collection and other fine nineteenth-century Japanese photographs at the Peabody Museum, David Odo seeks to answer the questions I have outlined here. In a confluence of critical museum history, material culture studies, and photographic history, he shows the museum's Japanese photographs not simply as a collection that supports other narratives and museum agendas, but as a revealing prism through which to think about the material performances of knowledge within the museum.[v] The reader is left with the sense not just of photographs "of" something, but of things in a museum that continue to have dynamic life within the institution, and which stand for a whole series of processes and practices that make museums what they are.

PREFACE

☙

*I*n 2005, during a preliminary research visit to the archives of the Peabody Museum of Archaeology and Ethnology for an exhibition I was organizing there, the archivist retrieved for me a box of early Japanese photographs.[1] I quickly realized why these objects were referred to informally as "art prints" at the Peabody, a museum not of "art" but of anthropology. I was astonished by the gorgeously preserved colors, in some cases so beautifully applied as to make them appear more like paintings than painted photographs. The soft water-colors seemed to have been absorbed by the albumen papers, and appeared to create a physical form beneath and beyond the surface of each image. The contrasts among the various colors used in the images, and between the colored and uncolored sections, created a convincing illusion of depth, an effect that must have charmed early collectors even more than we can imagine in today's visually oversaturated world.

One image in particular caught my attention that first day. The print, covered with a translucent sheet of protective paper and framed by an ivory-colored mat, appeared to be a portrait of a kimono-clad geisha, that ubiquitous symbol of Japan in the nineteenth century (see frontispiece). The museum's geisha photograph was a clichéd image, but a captivating one. The model's expression seemed at first to reveal nothing. But did I detect a thinly disguised boredom, or even, perhaps, a disdain for the viewer? Or was her studied composure merely the result of a lengthy exposure time? The photograph teemed with tropes of Japaneseness: the woman's elaborate hairstyle, glossy with camellia oil and punctuated with four fanciful hairpins of exotic design; the kimono, lightly clutched with her right hand, falling in graceful folds; and the shamisen, the lutelike instrument that was part of the geisha's stock in trade, held upright with her left hand. This photograph seemed to perfectly embody

certain nineteenth-century Western ideas about Japan—and Japanese women in particular—as hyperfeminine, subservient, and somehow inscrutable.

When I lifted the mat, I uncovered further layers of interest. The mount to which the delicate albumen print had been affixed was worn at the edges and discolored, indicating handling and age. The curatorial classification "Japan" was typed at the top left of the mount, and directly beneath the print was an embossed studio imprint bearing the name of one of early Japanese photography's most important figures, the Austrian Baron Raimund von Stillfried-Rathenitz.[2] Stillfried's portraits of Japanese women sold well and were collected in loose prints as well as albums. Above the imprint and to the right was a handwritten number, 663, possibly the studio index number scratched into the photograph's negative. Written on the mount's bottom left side in another hand were the names of the collector, (William) Sturgis Bigelow, and the donor, his niece Miss Mary Lothrop, along with the year of gift, 1927. Most critical, however, was the caption beneath the print, written in a script different from the other notations: "Shows very well how a Japanese woman's dress looks when properly put on. (A good type.)."

Initially, I assumed that it was a curator or an archivist who had decided to classify this image as an example of a "type" photograph, an image of a human subject made in an attempt to link visible physical characteristics (biological "types") with moral, cultural, and intellectual qualities (cultural "types"). To categorize a photograph coming into the museum in the 1920s as a "type"

Detail of frontispiece, *Singing Girl ("A good type")*, showing Bigelow's handwritten annotation on the paperboard mount. PM 2003.1.2223.310 (101160028).

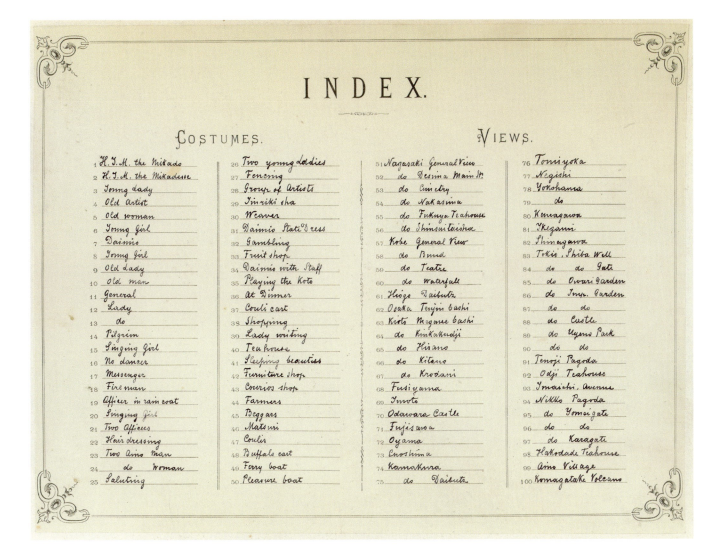

INDEX.

COSTUMES.

1 H.I.M. the Mikado
2 H.I.M. the Mikadesse
3 Young lady
4 Old Artist
5 Old woman
6 Young Girl
7 Daimio
8 Young Girl
9 Old lady
10 Old man
11 General
12 Lady
13 do
14 Pilgrim
15 Singing Girl
16 No dancer
17 Messenger
18 Fireman
19 Officer in rain coat
20 Singing Girl
21 Two Officers
22 Hair dressing
23 Two Aino Man
24 do Woman
25 Saluting

26 Two young Ladies
27 Fencing
28 Group of Artists
29 Inriki sha
30 Weaver
31 Daimio State Dress
32 Gambling
33 Fruit shop
34 Daimio with Staff
35 Playing the Koto
36 At Dinner
37 Couli cart
38 Shopping
39 Lady writing
40 Tea house
41 Sleeping beauties
42 Furniture shop
43 Courios shop
44 Farmers
45 Beggars
46 Matsuri
47 Coulis
48 Buffalo cart
49 Ferry boat
50 Pleasure boat

VIEWS.

51 Nagasaki General View
52 do Desima Main St.
53 do Cimetry
54 do Nakasima
55 do Fukuya Teahouse
56 do Shinsuitaisha
57 Kobe General View
58 do Bund
59 do Teatre
60 do Waterfall
61 Hiogo Daibutz
62 Osaka Tenjin bashi
63 Kioto Megane bashi
64 do Kinkakudji
65 do Hirano
66 do Kitano
67 do Krodani
68 Fusiyama
69 Imoto
70 Odawara Castle
71 Fujisawa
72 Oyama
73 Enoshima
74 Kamakura
75 do Daibutz

76 Tomiyoka
77 Negishi
78 Yokohama
79 do
80 Komagawa
81 Ikegami
82 Shinagawa
83 Tokio, Shiba Well
84 do do Gate
85 do Owari Garden
86 do Imp. Garden
87 do do
88 do Castle
89 do Uyeno Park
90 do do
91 Tenoji Pagoda
92 Odji Teahouse
93 Imaichi Avenue
94 Nikko Pagoda
95 do Yomei gate
96 do do
97 do Karagate
98 Hakodade Teahouse
99 Aino Village
100 Komagatake Volcano

Index page from the tourist album *Views and Costumes of Japan*, 1876. Raimund von Stillfried, photographer. Paper sheet, 19.1 × 23.7 cm (7½ × 9⅜ in.), on album page, 26.6 × 32 cm (10½ × 12⅝ in.). Courtesy State Library of Victoria, Australia, H95.62/1-100.

This index gives a good indication of the kinds of subjects featured in tourist souvenir albums, which typically included scenic views, temples and shrines, and images of samurai, peddlers, religious figures, and the imperial couple.

image would have been consistent with the Peabody's long history of collecting visual material, extending back into the nineteenth century. The practice also conformed to wider collecting conventions, which held that material culture could be studied and exhibited as embodiments of a given group. Museums of anthropology actively collected type photographs well into the twentieth century. But a comparison of handwriting samples revealed that the caption on this photograph was written not by a curator but by Bigelow himself, suggesting that the collector already considered the image to be anthropological data prior to its accession into the Peabody Museum.[3]

Another print of this image can be found in a deluxe edition album of one hundred of Stillfried's albumen prints. The album, which dates to 1876, is owned by the State Library of Victoria, Australia, and the photograph's title there is given as *Singing Girl* (there are two different images of "singing girls" in the album; this one is indexed as no. 20).[4] "Singing girl" was an early euphemism for a Japanese prostitute, and the term was often used to refer to geisha, highly trained female entertainers who were commonly misunderstood by Westerners to be prostitutes. "Singing girl" apparently retained enough titillation to remain a meaningful (and marketable) moniker for images of (purported) geisha, but it also provided sufficient cover to allow inclusion of these images in respectable souvenir albums (rather than collections of pornography, for example).[5]

Throughout this work, I am guided by Stillfried's photograph of the *Singing Girl* and Bigelow's captioning of it as "a good type." Thinking about the image helped me realize that it could be read simultaneously as a "singing girl" *and* as "a good type"—as both a nineteenth-century souvenir photograph housed in a national library and as a piece of data archived in an anthropological museum. It had become a museum object whose meanings continue to be made and remade over time. This study is only the latest iteration in its journey from artistic souvenir photograph to ethnographic museum object.

David Odo
Cambridge, Massachusetts

The Journey of
"A Good Type"

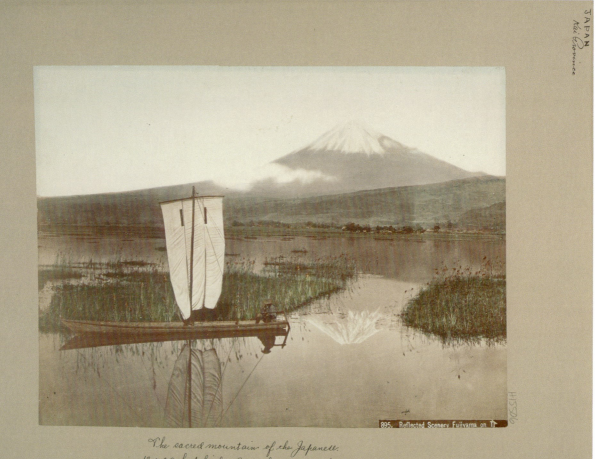

895. Reflected Scenery Fujiyama on T⊢

The sacred mountain of the Japanese.
12.400 feet high. It is found as a background
in most of the painting on their china and porcelain.

INTRODUCTION

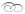

*H*ow could a souvenir photograph such as the *Singing Girl*, produced to appeal to foreign visitors to an exotic land, become scientific data—"a good type"—years, even decades, later? This is the essential question that confronts the viewer of the remarkable collection of photographs of Japan in Harvard University's Peabody Museum of Archaeology and Ethnology. These photographs were mostly created to supply the booming foreign tourist trade in the early days of Japan's modern engagement with the West, but they ended up representing Japanese culture and Japanese *bodies* as part of one of the world's foremost anthropological collections.

The Peabody's rich collection of early photographs produced in Japan was built through a combination of museum purchases and gifts by several

Reflected Scenery Fujiyama on T[okaido], c. 1880s. Variously attributed to Kimbei Kusakabe or Kihei Tamamura. Hand-tinted albumen print mounted on paperboard. Print: 19.7 × 25.8 cm (7 ³/₄ × 10¹/₈ in.); mount: 27.9 × 35.5 cm (11 × 14 in.). Collected by W. A. Dunn. Gift of W. A. Dunn, 1922. PM 2003.1.2223.418 (101420022).

This scenic view of Mount Fuji was published repeatedly by numerous Japanese studios over several decades in the late nineteenth and early twentieth centuries, making attribution extremely difficult. In addition, with each repackaging the image was slightly cropped in order to remove the previous studio's title and catalogue number, which had been scratched into the negative. As a result, later images appear to have a narrower focus than earlier ones. Often, as in this caption (possibly in Dunn's hand), the volcano was erroneously referred to as "Fujiyama"—a common transliteration error at the time that attached an alternate pronunciation of the Japanese character for "mountain" (*yama*) after "Fuji." The word would correctly be pronounced "Fujisan" in Japanese, rather than "Fujiyama."

important donors, whose individual contributions shaped the character of the archive. The photographs were acquired during Japan's Meiji era (1868–1912), as the country transformed from a feudal system controlled by a military government to an imperial, industrial, and military power with global ambitions. By examining these images within the context of early photography, anthropology, and foreign travel to Japan, I seek to understand how it was possible to (re)classify these once-souvenir images as *anthropological* photographs. I also explore the connections between the formation of the Peabody's collection and the visual economy through which the images flowed, the sets of developing relations between Japan and other governments, and the ideas and attitudes of outsiders toward Japan.

In the course of my investigation, I consider the photographic production of an imagined Japan, including work created by some of the most important early studios, which had mainly been established by foreign photographer-entrepreneurs before being replaced by Japanese-run studios as the nineteenth century drew to a close. The photographic output of these studios provides a fascinating look into some material manifestations of foreign attitudes about Japan during the period, many of which continue to resonate today.

Operating on a natural history model, nineteenth-century social scientists constructed the idea of human "types": normalized categories of people based on ostensibly standard physical characteristics, which were in turn associated with certain moral or cultural qualities. Many interested Westerners feared that traditional Japanese "types" would be eradicated by the onslaught of Western civilization and modernity, echoing what had already occurred in colonized regions of the world. Photography, whose invention coincided with the industrial revolution and the late colonial era, became inextricably entwined with the scientific study of the "vanishing type," as anthropometric studies used photography to distinguish physiognomic traits throughout the colonized world. The Peabody's archives provide ample evidence of this, and I examine images of North American groups, Japan's indigenous Ainu population, and other comparative materials to explore the blending of anthropological study and colonial biases in photography of the cultural "other."

In Japan, the idea of the vanishing type was integral to the production and consumption of the earliest photographs. Souvenir forms of photography merged with scientifically inflected ideas about types and resulted in commercial images of Japanese subjects that at the time read equally well to tourists

and to anthropologists. In their attempt to salvage disappearing aspects of Japanese culture through images, these photographs are deeply connected to global image-making practices typically associated with colonized peoples. My exploration of these photographs considers this complicated context of creation and circulation in order to demonstrate the significance and potential of ongoing (and future) anthropological engagements with photographic archives.

394.

CHAPTER 1

A Valuable Collection

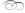

*Valuable collections of photographs have been received,
notably the Sturgis Bigelow collection of colored
anthropological prints of the people of Japan, the gift
of Miss Mary Lothrop.*

—61st Report on the Peabody Museum
of American Archaeology and Ethnology[6]

Hundreds of prints are found in the Peabody's Bigelow collection of
Japanese photographs, donated by his niece in 1927, and many hundreds more
reside in the museum's other collections of early photographs of Japan. The
Bigelow photographs include exquisitely hand-tinted albumen prints in superb
condition. Their subtle colors—hand-painted on the surface of the print—and
carefully composed tableaux of "exotic" Japanese scenes engage the viewer
from the first glance.[7] But the surface beauty of these alluring images can
obscure the complexity of their story and the wider context of the collections.
These photographs reflect much more than a simple fascination with the exotic
or an uncomplicated desire to collect pretty pictures. As the excerpt from the
Peabody's 1926–27 annual report reveals, the Bigelow prints were considered
to be works of scientific value, and they were accessioned into the museum's
archival collections as "anthropological prints."

Man in samurai armor, 1870s. Raimund von Stillfried. Hand-tinted albumen print, 24.8 ×
18.6 cm (9 3/4 × 7 3/8 in.). Collected by William S. Bigelow, 1880s. Gift of Mary Lothrop, 1927.
PM 2003.1.2223.396 (101170017).

The Bigelow prints are just one of many collections of early photographs of Japan that came to the Peabody Museum through numerous gifts from collectors and other individuals, as well as by purchase and barter, over several decades. The museum owns over 1,300 individual photographs of Japan in a variety of formats: albumen prints variously produced as loose prints, stereocards, cabinet cards, and cartes-de-visite, as well as glass lantern slides.[8] They reside within a massive archive of over 500,000 prints and negatives collected from all over the world.

Most of the material was produced and collected in Japan's Meiji period (1868–1912), an era of hitherto unprecedented contact between Japanese and Westerners. In the course of several decades, Meiji-era Japan underwent a radical transformation from a mostly isolated feudal country into a powerful modern nation. The ever-increasing presence of foreigners in a country that had been largely separated from the world outside its borders for approximately 250 years proved both shocking and enlightening to insiders and outsiders alike. Photographs were an integral part of this encounter, guiding viewers on a visual journey through the island nation in both geographic and metaphorical terms. Images documented real people, places, and objects, and the objective appearance of photographs must have been convincing to many viewers as evidence of Japanese culture. At the same time, photographs created and sustained Western stereotypes about Japan, ostensibly offering visual proof — often in concert with written captions — for these fantasies, picturing models in costume as samurai and geisha, for example, and staging domestic scenes in studio interiors, which passed for glimpses into the authentic lives of exotic Japanese subjects. When the shogunate, the country's hereditary military rulers, designated certain ports as "treaty ports" in 1854, Japan became accessible to the Western world for the first time since the seventeenth century.[9] Foreigners were allowed to live and conduct business in a relatively unrestricted manner in these port cities, and within a few years diplomats, businessmen, and pleasure travelers began to arrive in steadily increasing numbers. Along with the earliest visitors came the art and technology of photography, and collecting photographs of Japanese subjects became de rigueur among foreigners in Japan.

The foreign clientele for photography was not exclusively tourists, and a range of images and formats was produced for these consumers. Those who lived in Japan for multiple years, for example, purchased ready-made photo-

graphs and albums, just as tourists did, but often commissioned work made expressly for their own collections. Subjects included themselves and their families, their wider circle of foreign and Japanese colleagues, friends, and servants, as well as their dwellings, property, and travels in Japan.[10] This kind of photography was understandably less common than the enormous output of tourist photography, which, although produced for a similarly elite and overlapping clientele, was a mass-market product. The studios making these photographs operated in a highly competitive market, advertising relentlessly in guidebooks and hotels targeted at foreign visitors. The Japanese photographs in the Peabody Museum, like those in other Western museums, were primarily produced for the tourist market.

Photographs were also exported to Western countries, where they stimulated travel to Japan and entertained those armchair travelers who did not make the trip in person. Talented and entrepreneurial photographers—initially Europeans and Americans but followed almost immediately by Japanese — worked furiously to keep up with demand. Skilled photographers, including the Italian-British Felice Beato[11] (1832–1909), the Austrian Baron Raimund von Stillfried-Rathenitz (1839–1911), his probable Japanese protégé Kimbei Kusakabe (1842–1934), and Nagasaki-born Hikoma Ueno (1838–1904), produced massive quantities of images that conformed to foreign notions of "old Japan." One such image is the expertly hand-colored half-length portrait by Stillfried of a man in samurai armor (see p. 6). An icon of Japanese masculinity in nineteenth-century Western thinking about Japan, the samurai was seen as the embodiment of a native Japanese spirit grounded in the nation's recent feudal past. Samurai were much admired, or feared, depending on the context. However, photographs such as this were for the most part produced and circulated after the Meiji emperor had stripped the warrior class of certain privileges in 1871, when samurai were required to cut off their topknots and wear their hair in Western style. The creation of the Imperial Army in 1873 further disempowered samurai, depriving them of the right to bear arms and ending their monopoly on military institutions.

Such images of "old Japan," then, were produced not to represent a lived reality in Japanese society but to meet the expectations of Western travelers and supply the market for souvenir photographs. Even today, these same works are especially prized by collectors of early photography.

The Collectors

The collectors who contributed to building the Peabody Museum's Japanese collection included several prominent men (and so far as we know, they were all men) with deep Harvard ties—anthropologists and archaeologists, for the most part, whose work advancing scientific knowledge was well regarded in their respective fields. William Sturgis Bigelow (1850–1926) was one of an unknown number of named and anonymous collectors who donated, sold, or otherwise had their photographs deposited in the museum's archives, and his collection comprises the largest single group of early Japanese prints in the Peabody. Bigelow eventually became known primarily as an art collector and a convert to and proponent of Buddhism, but he was also a scientist with degrees from Harvard College (1871) and Harvard Medical School (1874), and advanced European medical training. He practiced and lectured on surgery at Massachusetts General Hospital and Harvard University.

Bigelow was the only son of prominent Boston Brahmins. His father, Henry Jacob Bigelow, was a well-known surgeon, and his mother, Susan Sturgis Bigelow, who died when he was three, was the daughter of a wealthy China-trade merchant. He developed a passion for Japanese art during his five years studying medicine under Louis Pasteur in Paris in the 1870s, a period when *Japonisme*, the craze for Japanese art and design, was at its height. In Paris he met Siegfried Bing, the famous dealer in Japanese art. When he returned to the United States in 1881 Bigelow exhibited at Boston's Museum of Fine Arts hundreds of Japanese art objects he had collected in Europe. In 1882 he journeyed to Japan with the natural scientist Edward Sylvester Morse (1838–1925), also a major collector of Japanese objects, many of which he sold or gave to the Peabody Museum. Morse became famous for his archaeological work and helped introduce modern Western scientific theories and methods to Japan in his capacity as a faculty member at the Tokyo Imperial University, where he organized a department of natural history and also helped establish the Tokyo Imperial Museum (now Tokyo National Museum).[12]

Bigelow stayed in Japan for seven years, traveling frequently throughout the country with Morse and the eminent art historian of Japan Ernest Fenollosa (1853–1908). He amassed an enormous collection of Japanese and Chinese art, as well as large collections of seeds, which he sent to Harvard's Arnold Arboretum. Bigelow eventually became a Buddhist priest and had his ashes divided and interred at his temple in Japan and in Mount Auburn Cemetery in Cambridge.

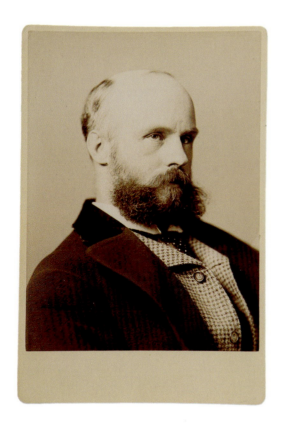

William Sturgis Bigelow (1850–1926), 1882–89. Augustus Marshall. Albumen silver print on cabinet card, 15.9 × 10.8 cm (6¼ × 4¼ in.). Courtesy of Special Collections, Fine Arts Library, Harvard University. 119.1976.3293/FAL6328755.

This portrait was made in Boston, likely around the time Bigelow left for Japan in 1882 or shortly after his return in 1889.

RIGHT
Bigelow in Kyoto, c. 1885. Photographer unknown. Albumen print, 34.4 × 23.7 cm (13⁹/₁₆ × 9⁵/₁₆ in.). PM 2003.0.17.17.1 (98970064).

 Like other visitors to Japan, Bigelow seems to have been enchanted by the artful photography on offer, and in the 1880s he assembled a substantial collection of photographs of Japanese subjects. Bigelow's collection—given to the museum on his behalf in 1927 by his niece, Mary Lothrop—is today the Peabody Museum's best-known group of early Japanese photographs. Selections from its over four hundred prints have appeared in numerous publications and have been prominently featured in two exhibitions.[13]

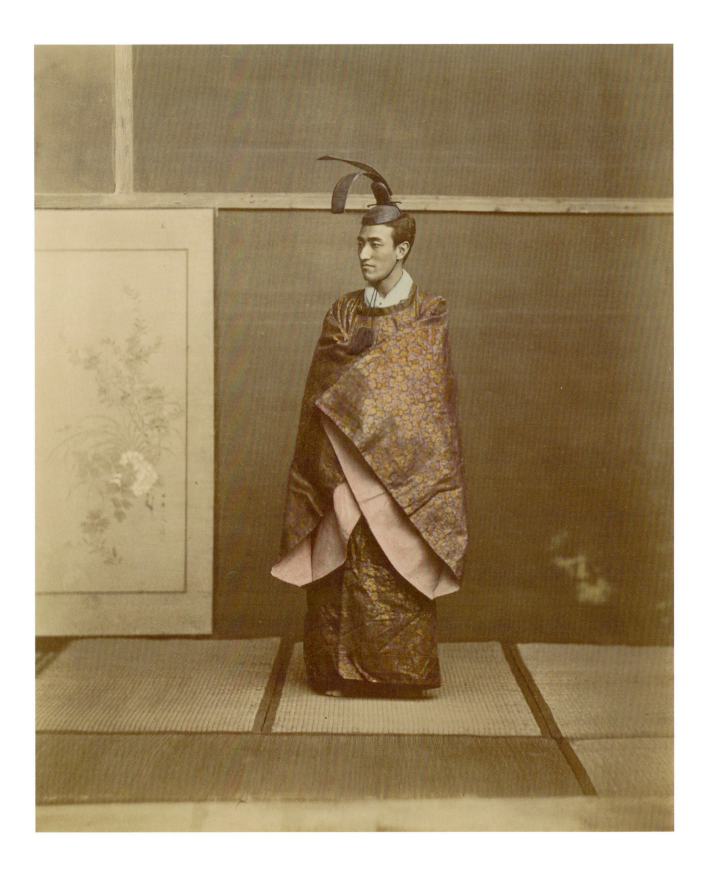

Of the wide-ranging works from Asia that Bigelow collected, only the photographs were given to the Peabody Museum; most of his other collections formed the basis for the Asian department at Boston's Museum of Fine Arts.[14] This might have been done partly because at the time photographs were often considered "informational" and objective documents, readily amenable to ethnographic study. But it was also likely the result of ambiguous contemporary thinking that categorized Japan—and therefore objects produced in Japan or with Japanese subjects, including photographs—variously as either "civilized" or "savage," a dichotomy to be discussed at greater length later in this text. If a donor or curator considered the source society, such as France or Italy, to be "civilized," its objects were more likely to be accessioned into a fine arts museum; if a culture were categorized as "savage"—usually meaning the non-Western world—its material culture would be of interest mainly to anthropology collections.

The photographs in Bigelow's collection were most likely produced between the 1860s and the 1880s, with the majority printed in 1876–77. They were almost certainly purchased in the 1880s during his Japan sojourn. Much of the other Japanese material in the Peabody's photographic archives was likely produced and sold by commercial studios during this same general time period. Bigelow himself was an amateur photographer, and he could have produced some of the anonymous photographs in the collection that bears his name, but it has not been possible to positively attribute any of the images to him.

Another set of photographs of Japan, which includes 131 late nineteenth-century prints, came to the Peabody Museum from the John S. Paine collection as part of his larger group of 174 images from many regions of the world, including Africa and South Asia. Paine (1823–1903) and his son James L. Paine, who donated his father's photographs to the Peabody in 1936, made gifts of funds and objects to several Harvard collections, including the Peabody and the Semitic Museums (see p. 14).

George Byron Gordon (1870–1927), renowned archaeologist, explorer, and professor of anthropology, gave hand-tinted photographs of Japan to the Peabody in 1898. Gordon received his doctorate in anthropology from Harvard

Man dressed in imperial court costume, 1870s. Studio of Stillfried & Andersen Co., Raimund von Stillfried, photographer. Hand-tinted albumen print, 23.4 × 19.2 cm (9¼ × 7½ in.). Collected by William S. Bigelow, 1880s. Gift of Mary Lothrop, 1927. PM 2003.1.2223.343 (101160014).

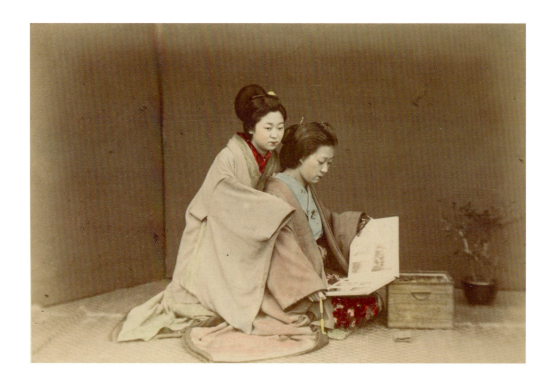

Japanese Ladies Looking at a Photograph Album (Scenes in Japan), c. 1880s. Photographer unknown. Hand-tinted albumen print, 9 × 13.1 cm (3½ × 5⅛ in.). Gift of James L. Paine, 1936. PM 36-26-60/15986.102 (101150001).

Images of people looking at albums of photographs are often found in nineteenth-century Japanese tourist albums. Perhaps this was both social commentary and clever marketing by the studio. The title given here comes from a caption handwritten (presumably by the collector) on the verso.

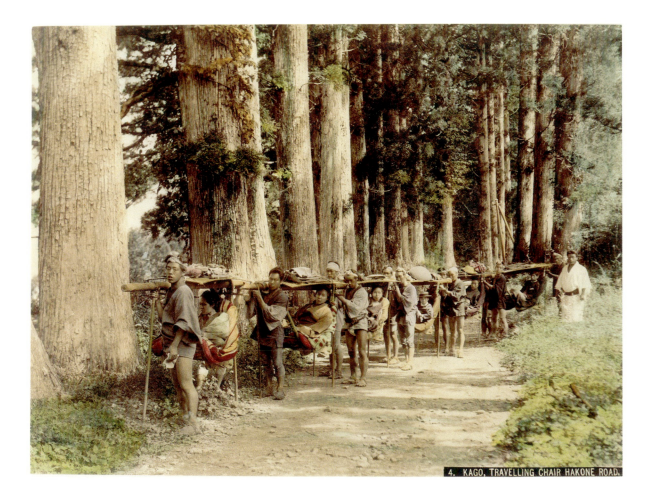

4. KAGO, TRAVELLING CHAIR HAKONE ROAD.

Kago, Travelling Chair, Hakone Road, 1880s. Studio of Kimbei Kusakabe. Hand-tinted albumen print, 19.8 × 26.2 cm (7 ¾ × 10⅛ in.). Collected by George B. Gordon, 1898. Gift of George B. Gordon, 1898. PM 2003.1.2223.419 (60741071).

Images of *kago* featured heavily in Meiji-era photographs. Accompanying captions in tourist albums and travel writing often mentioned the muscled physique of porters. This photograph, however, is equally concerned with the tree-lined road to Hakone, a famous tourist destination with numerous hot spring resorts, located relatively close to Tokyo and near Mount Fuji.

in 1894, headed the Harvard Copán expedition, and taught anthropology at the college before moving to the University of Pennsylvania in 1903, where he served as curator and director of the Free Museum of Science and Art (now the University of Pennsylvania Museum of Archaeology and Anthropology). His gift consists of forty-four prints of people and landscapes, and contains many striking images (see p. 15). Overall, the Gordon collection is not as well preserved as the Bigelow materials, but it is similar in content if not quality. The difference probably reflects not only Bigelow's artistic interests and considerable wealth, but also the proliferation of low-cost, mass-produced photographs at the time Gordon was collecting and the simultaneous decline in quality of souvenir photographs in Japan as the nineteenth century drew to a close.

Another important donor to the Peabody's collection was Hiram Milliken Hiller (1867–1921), a physician who, like Gordon, was also a curator at the Free Museum of Science and Art. Hiller traveled to Asia several times between 1895 and 1901, and he made important contributions to the Philadelphia museum's ethnographic and photographic collections.[15] His journey in 1901 included an expedition to Hokkaido, where he made a large collection of

Aino, 1901. Hiram Hiller. Albumen print on paperboard mount. Print: 17.9 × 12.8 cm (7 × 5 in.); mount: 30.3 × 25.7 cm (11⅞ × 9⅞ in.). Gift of Hiram Hiller, 1902. PM 2004.29.15389 (101160020).

This image shows an Ainu man using an *ikupasuy* (prayer stick), erroneously rendered as "mustache lifter" in much of the Western-language literature about Ainu culture. The caption on the verso of the print states: "An Ainu drinking sake showing method of lifting moustache and raising the bowl." The ikupasuy was and remains a sacred object, an intermediary that delivers messages between the gods and worshipers. It is also used to make liquid offerings, usually sake, although in the past millet beer was typically used as an offering. This photograph was likely staged to conform to Western stereotypes about the meaning of the ikupasuy. The mistaken idea of the prayer stick as a "mustache lifter" in European writing can be traced back at least as far as the mid-sixteenth century to the Portuguese Jesuit missionary Luís Fróis. The misunderstanding continues to the present day. The spelling of the title term "Aino" (on the front of the mount) was a common mistransliteration of "Ainu," which means "people" or "humans" in the language of the indigenous peoples of northern Japan.

AINO

Japan

HI5389

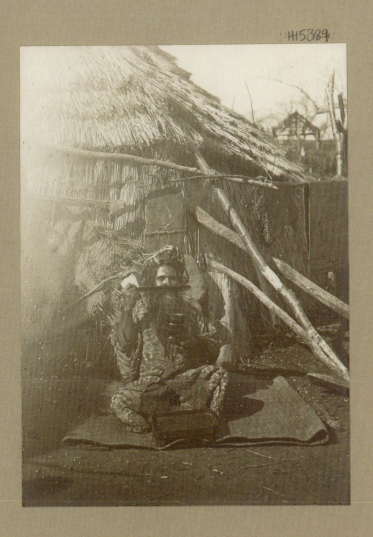

OVER

nearly three hundred ethnographic and archaeological objects of the Ainu people of northern Japan for that museum.

Hiller produced his own photographs of the Ainu, and in 1902 he gave the Peabody fifteen mounted prints, annotated with handwritten captions that describe and date each image. This small but significant group of Ainu images falls easily within the received notion of what constitutes an "anthropological" photograph: it was produced by an anthropologist-photographer who trekked to a remote location to photograph "natives" in a state of nature, performing their culture for the camera. In fact, however, Hiller's Ainu prints, along with a small number of similar photographs that include some from British explorer and writer Charles H. Hawes (1867–1943), form only a very small fraction of the Japanese collection.[16]

Approximately half of the total collection of early Japanese photographs in the Peabody can be positively connected to a named donor or seller, but we can only speculate as to how the remaining prints ended up in the museum's archives. The wider point, however, is that even among the known collectors, although nearly all had strong connections to science through medicine, anthropology, or archaeology, virtually no stereotypically "anthropological" images of Japanese subjects were collected, especially if we exclude the Ainu photographs. The Japanese photographs were mainly made in commercial studios using models and props, and many were later artfully hand-colored—circumstances of high artifice that would seem to negate any possibility of reflecting an "objective" reality, which photography was purported to do. There was, however, much cross-pollination between the scientific and commercial (or touristic) photographic worlds, which resulted in the possibility of discerning multiple meanings within this new technology that had promised fixity of fact.

The Peabody's early Japanese collection must be considered as a synthetic creation put together over decades within the museum, an amalgamation of more or less "organic" collections created by individuals, including Bigelow, with different collecting agendas. In a contemporary reading of this collection, the archive is itself part of the chain of meaning-creation of the photographs. An attempt to understand the photographs begins with an appreciation that the archive within which they are contained is a cultural space in its own right, constituted by its own processes, hierarchies, and structures.[17] The photographs that constitute this archive traveled a long distance physically and conceptually

from their studios of origin in Yokohama and elsewhere in Japan to the archives of the Peabody Museum in Cambridge, Massachusetts. Examining how the photographs made this journey begins with the journeys the photographs themselves inspired in Western travelers.

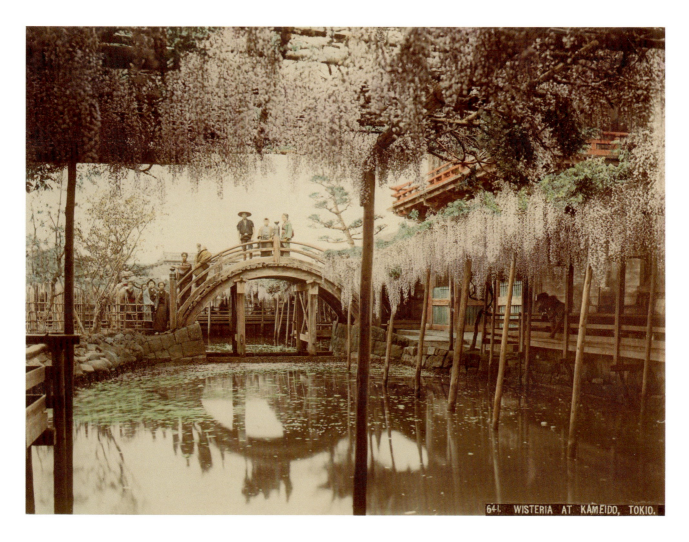

641. WISTERIA AT KAMEIDO, TOKIO.

Wisteria at Kameido, Tokyo, 1880s. Studio of Kimbei Kusakabe. Hand-tinted albumen print, 19.9 × 26.2 cm (7 ¾ × 10 ¼ in.). Collected by George B. Gordon, 1898. Gift of George B. Gordon, 1898. PM 2003.1.2223.270 (101150017).

Many landscape and architecture photographs from this period were patterned after famous *ukiyo-e* (woodblock prints). This image of Tokyo's Kameido Tenjin shrine, with its iconic *taiko-bashi* (drum bridge) and famed wisteria in full bloom, follows a well-known 1856 print by Hiroshige Andō and others (see p. 22). The photographic negative likely originated in the studio of Felice Beato or Raimund von Stillfried, but the Peabody's print was probably purchased from Kimbei Kusakabe's studio in 1898, when the collector, George Byron Gordon, was in Japan. This illustrates a familiar trajectory of the shifting of photography studios' inventory over several decades. Studios acquired the stock of others as they closed, and loose copyright laws did little if anything to stop the unauthorized appropriation of images by competing studios. It also reflects the long shelf life of images in the tourist market, which preferred the "traditional" themes of early photographs to images that depicted modern Japanese society.

CHAPTER 2

Visual Journeys

∞

*I bought photographs—for some reason or other everyone was
selling off photographs. I believe I bought every photograph
that had ever been taken in Japan, cabinet size, coloured, for a
halfpenny each. The wiseacres told me they would not last,
but thirteen years afterwards they do not look any worse than
they did; and no matter what subject in Japan I am writing
about, my photographic museum never fails me.*

—DOUGLAS SLADEN[18]

British author Douglas Sladen (1856–1947) used his Japanese "photographic museum" as an *aide-mémoire*, underscoring the photograph's role as a stand-in for the past that ostensibly possesses a truth-value that can illuminate thinking about an entire culture or country. Souvenir photographs had become wildly popular in Japan by the time Sladen made his purchases in the late nineteenth century. And however hyperbolic his playful claim of having bought "every photograph that had ever been taken in Japan," his account reflects their extraordinary popularity among tourists and other visitors.

SOUVENIR PHOTOGRAPHY IN JAPAN

If for Sladen and others who had actually traveled to Japan photographs provided a record, a virtual stand-in for the real-world place, they also made possible a visual journey through Japan for foreigners who admired and imagined the country from afar. These journeys of memory and fantasy were constructed with the products of the burgeoning commercial photograph market, which

21

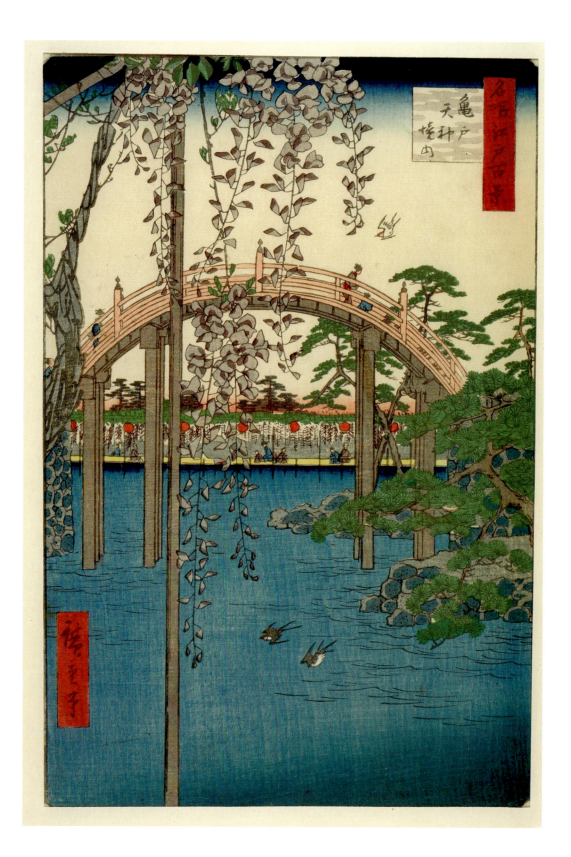

first began to emerge in Japan in the 1850s and 1860s to supply increasing demand. Pioneers of the early market were mainly foreigners, among them the celebrated entrepreneur-photographer Felice Beato, who had gained renown as a photographer reporting on the Crimean War in 1855 prior to making his way to Asia. Beato went on to photograph the Indian Rebellion of 1857 and the Second Opium War in China in 1860 before moving to Japan and opening a studio in Yokohama in 1863 with a partner, Charles Wirgman (1835–1891).

One of the most prolific and successful photographers of this early period, Beato is credited with having introduced and popularized the hand coloring of photographs in the Japanese market, making use of skilled local artisans from the *ukiyo-e* (woodblock print) trade to produce exquisitely tinted albumen prints. Beato is also often credited with having trained or employed a generation of Japanese photographers, including the great commercial photographers Kimbei Kusakabe and Hikoma Ueno, although there is no direct evidence to support this. It is clear, however, that his work had a tremendous influence on all early photographers in Japan because of his skill and commercial success. His photographs captured not only the era's most famous tourist sites but also elements of Japanese cultural life in a style that appealed to Western consumers. Beato worked in Japan from 1863 to 1877, and he sold his photographic stock—negatives, prints, and equipment—to the Stillfried & Andersen Co. before he left the country in 1884.[19]

Baron Raimund von Stillfried-Rathenitz, an Austrian aristocrat who first arrived in Japan as early as 1864, trained there with Beato beginning in 1868. His training was interrupted several times, however, by stints working for Dutch silk merchants, by military service for the Hapsburg Empire that took him to Mexico, and by a diplomatic position with the North-German Legation in Tokyo. Stillfried started his own studio in 1871 in Yokohama, then the center of the rapidly expanding Japanese photography industry, and he operated studios under several names during his career in Japan. Among these were

Inside Kameido Tenjin Shrine (Kameido Tenjin Keidai), 1856. Hiroshige Andō. Number 65 from the series *One Hundred Famous Views of Edo (Meisho Edo Hyakkei)*. Woodblock print in *ōban* format; ink and color on paper, 35.4 × 24.4 cm (13 7/8 × 9 5/8 in.). Courtesy Harvard Art Museums/Arthur M. Sackler Museum, Gift of the Friends of Arthur B. Duel, 1933.4.151. Imaging Department © President and Fellows of Harvard College.

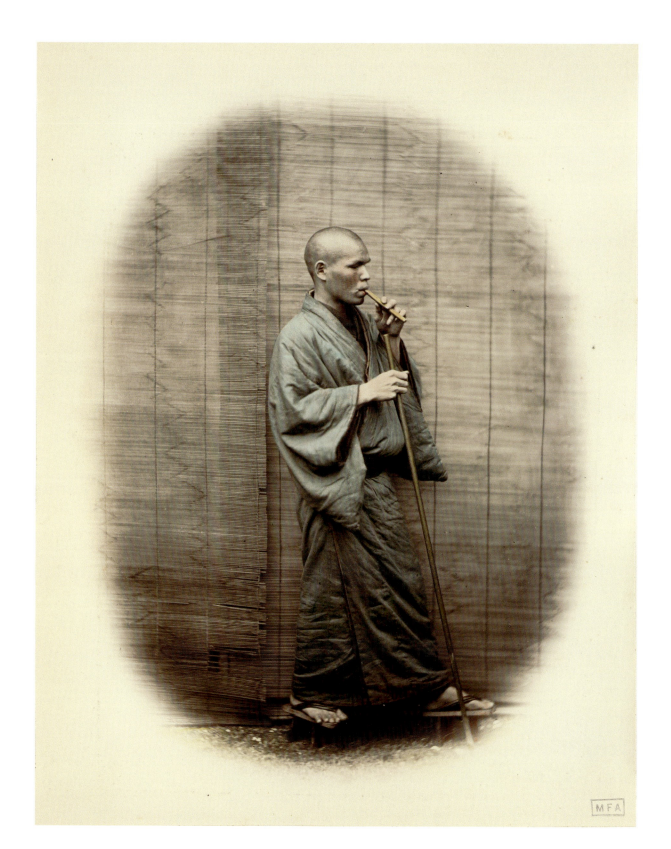

Stillfried & Co., the Japan Photographic Association, and Stillfried & Andersen, with business partner Hermann Andersen; the Yokohama Co.; and the Japan Photographic Association. Stillfried left Japan for Hong Kong in 1881 and returned to Austria in 1883, and Andersen continued the business for several years on his own.

Stillfried's work is key to understanding the Peabody Museum's collection because his studio's output comprises the museum's largest single group of photographs related to Japan, and his prints are the best-preserved and best-known works in the Bigelow collection. Stillfried is especially renowned for his studio portraits of traditionally coiffed, silk kimono–clad women, although his landscape scenes have also recently received renewed critical acclaim.[20] His photographs were skillfully composed, many were elegantly hand-tinted, and all were sought-after souvenirs for tourists and resident foreigners alike. They found favor among an elite Japanese clientele as well. The quality of Stillfried's work perhaps reflects his training as a painter, but was also influenced by Beato's expertly crafted and popular images. After purchasing Beato's studio and inventory in 1877, Stillfried later sold prints made from Beato's stock under his own studio's imprint without any acknowledgment of the original producer, as was often the case in that period.

But foreign photographers were not the only or even the most prolific producers of Japan's early commercial studio photographs. As the market strengthened in the 1860s, Japanese photographers entered the business in increasing numbers. By the 1870s there were over one hundred professional photographers working in Japan, and professional associations and journals began to emerge. Japanese photographers operated studios both inside and outside the treaty ports (to which foreign photographers were initially restricted), selling a variety

Amma, — or Shampooer, 1860s. Felice Beato. Hand-tinted albumen print, 28.5 × 22 cm (11¼ × 8⅝ in.). Photograph © 2015 Museum of Fine Arts, Boston, 2010.580.24. Collected by William S. Bigelow, 1880s. Gift of Mary Lothrop, 1926. Given to the William Morris Hunt Library in 1926; transferred to the Museum of Fine Arts Boston collection in 2010.

Images of blind masseurs, referred to in English as "shampooers," found a lasting presence in tourist albums. Beato's albums carried lengthy explanatory captions, which, for this image, stated that *amma* announce their presence by blowing on a whistle, and in addition to their massage services, operate as short-term moneylenders, albeit charging exorbitant interest rates.

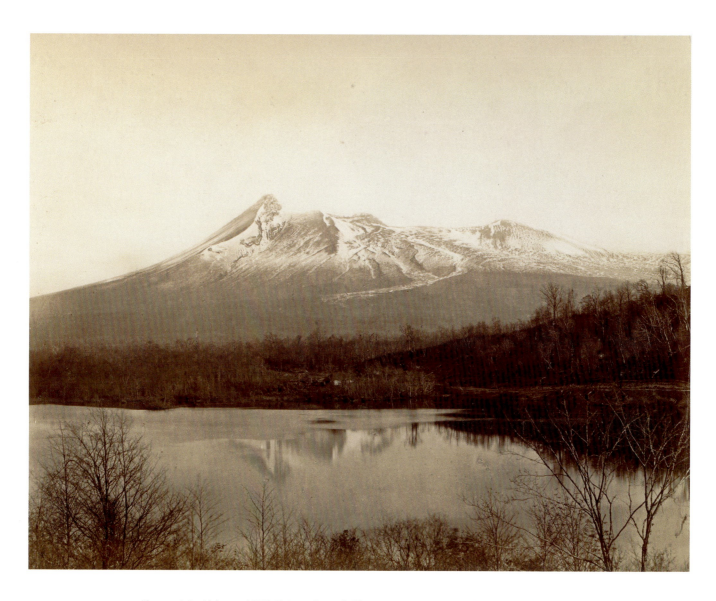

Komagatake Volcano, 1876. Raimund von Stillfried. Albumen silver print, 19.1 × 23.7 cm (7 1/2 × 9 1/4 in.), on album page, 26.6 × 32.0 cm (10 1/2 × 12 5/8 in.). Courtesy of State Library of Victoria, La Trobe Picture Collection, H95.62/100.

Landscape images such as this stunning view of Mount Komagatake, a stratovolcano in Hokkaido (northern Japan), demonstrate Stillfried's artistry in photographing Japan's landscapes.

of ready-made prints as well as on-the-spot portrait services.[21] Foreigners, who were not typically allowed to visit "native areas" outside the treaty ports (where most of the Japanese-run studios were located) thus had access to a relatively small percentage of the existing commercial studios and tended to patronize European businesses in the early years of the trade.[22] By the time Douglas Sladen purchased his photographs at the end of the nineteenth century, however, nearly all the foreign photographers working in Japan had been replaced by Japanese photographers, who now supplied the lucrative tourist market. As Sladen intimated in the passage quoted above ("The wiseacres told me they would not last . . ."), there was a general perception that the quality of these mature-market souvenir photographs had declined in the era of high competition, low prices, and burgeoning tourism.

A Journey through "Old Japan"

The subject matter of the Stillfried photographs, as well as of those in the wider Peabody Museum collections, reflects a Western romanticized notion of Japan that was common at the time. Stereotyped images continued to resonate among foreigners—both as intangible ideas and in material objects such as photographs—as Japan was reimagined from a closed kingdom into a tourist destination. In the 1850s several Western nations with economic interests in Asia pressured the shogunate into allowing foreigners to live, conduct business, and travel within Japan's borders (albeit with limitations). Outside the country, the development of modern infrastructure—such as the inauguration of regular steamship service between San Francisco and Yokohama in 1867, and, in 1869, the opening of the Suez Canal and the start of transcontinental rail service in the United States—ushered in a boom in foreign travel to Japan that was to last well into the first decade of the twentieth century. In 1880 certain domestic travel restrictions within Japan were relaxed, further encouraging tourism. Tourism to Japan grew so large, in fact, that the term "globetrotter" was coined by resident foreigners in mocking reference to the large numbers of foreign tourists flocking to Japan during this time.[23]

Tourists visiting Japan as part of the nineteenth-century travel boom generally followed a predictable route that was easily learned from the numerous and widely published English and other European-language guidebooks, travelogues, and journalistic accounts. Lavishly illustrated with photographs or

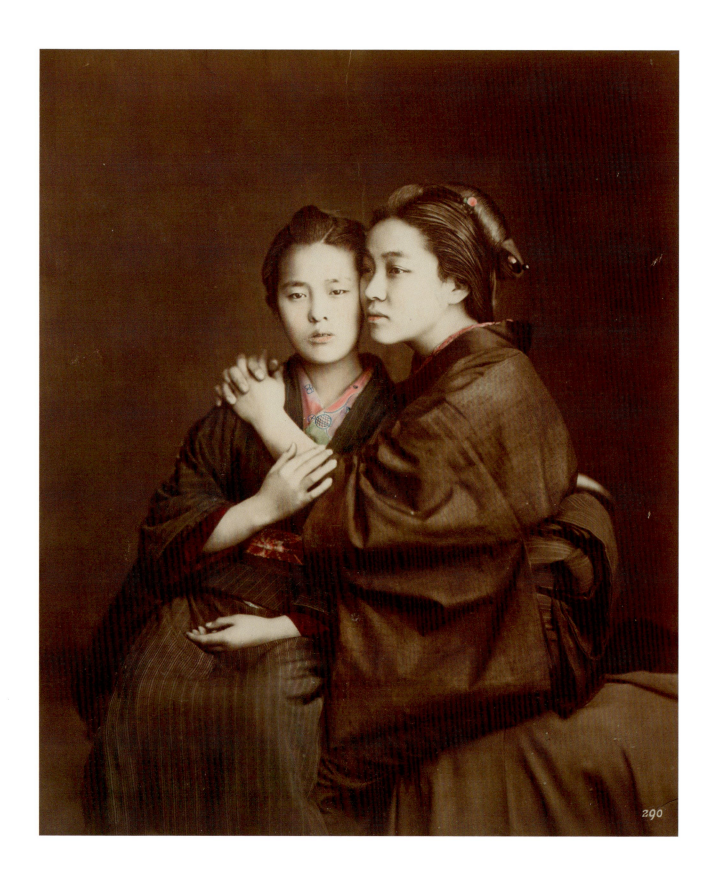

engravings based on photographs, these publications featured heavy advertising from studios. Photographs themselves were often referred to as must-have souvenirs. One such guidebook, Sladen's *The Club Hotel Guide* (1891), went so far as to recommend stopping at a studio as a way to determine what was important to see during one's visit:

> A visit to Farsari's [Yokohama photography studio] will be found very entertaining, for one can get no surer index of what is worth seeing in Japan than by looking through Farsari's cabinets of photographs, which embrace a large portion of the Empire. Tamamura's photographic establishment should also be visited. . . . These establishments will take at least a day to do properly, but once done, the visitor will not only have inspected some of the most important stocks in Japan, but have picked up a variety of information about the country which he could hardly pick up anywhere else.[24]

There is no way of knowing how many travelers to Japan took Sladen's advice and used photographs as an "index of what is worth seeing," but tourists undoubtedly collected many thousands of albums of photographs as souvenirs. The images were available in various forms: in prepackaged, prebound albums; as loose photographs that could be ordered by the purchaser and bound in the studio on the spot; and as loose prints that could be bound once the traveler returned home. The album pages contained generic, tourist-friendly images of Japanese people, posed and costumed according to stereotype—women mainly as geisha and servant girls, and men as samurai warriors, religious figures, and laborers. Japanese houses and religious architecture such as Shinto shrines and Buddhist temples were also popular subjects, along with scenic views of Mount Fuji, cherry trees in full blossom, and gardens in bloom.

Two women, c. 1870s. Studio of Stillfried & Andersen Co., Raimund von Stillfried, photographer. Hand-tinted albumen print, 23.5 × 19.2 cm (9¼ × 7⅝ in.). Collected by William S. Bigelow, 1880s. Gift of Mary Lothrop, 1927. PM 2003.1.2223.27 (101380029).

The composition of this image reflects a well-used pose from a standard repertoire that can be found among all the major early studios in Japan.

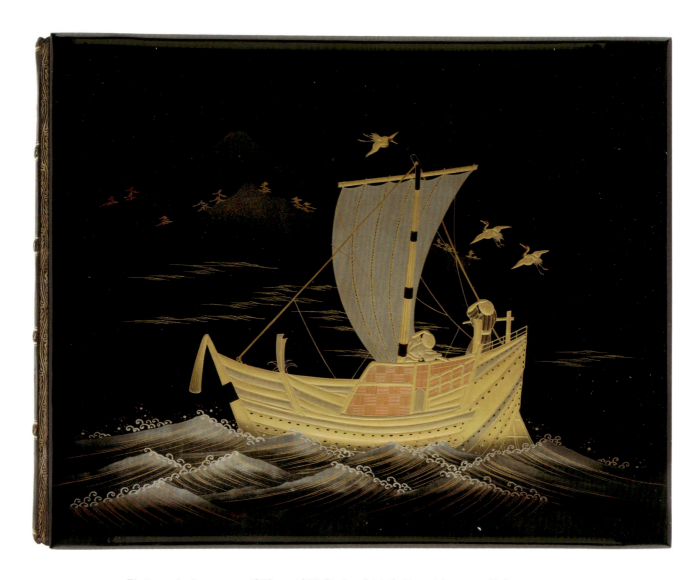

Photograph album cover, 1872 – c. 1887. Studio of Adolfo Farsari. Lacquer, 28.5 ×
35.9 × 4 cm (11¼ × 14⅛ × 1½ in.). Courtesy of Harvard Art Museums/Fogg Museum,
Gift of Janet and Daniel Tassel, 2007.219.3. Imaging Department © President and Fellows of
Harvard College.

Album covers were produced in a myriad of designs, but typically featured common elements
that tourists would have easily recognized as "Japanese." This cover shows the requisite
image of Mount Fuji in the background, with a sailboat at sea encircled by flying cranes in
the foreground.

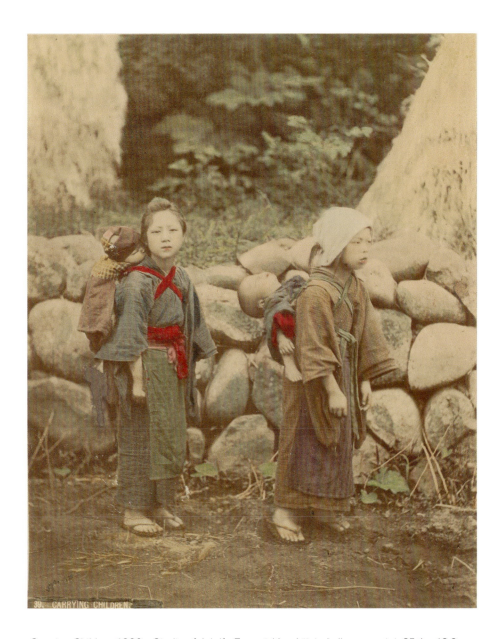

Carrying Children, 1880s. Studio of Adolfo Farsari. Hand-tinted albumen print, 25.4 × 19.9 cm (10 × 7 ⅞ in.). Collected by George B. Gordon, 1898. Gift of George B. Gordon, 1898. PM 2003.1.2223.6 (101160002).

The studio of Adolfo Farsari (1841–1898), an Italian-born American who worked in Yokohama in the 1880s, created this photograph of young girls carrying infants on their backs. Farsari purchased the Stillfried & Andersen studio and many of its negatives in 1885, and was one of the last foreign photographers to enjoy commercial success in Meiji-era Japan.

Courtesan with attendant, 1870s. Studio of Stillfried & Andersen Co., Raimund von Stillfried, photographer. Hand-tinted albumen print, 23.5 × 19 cm (9¼ × 7½ in.). Collected by William S. Bigelow, 1880s. Gift of Mary Lothrop, 1927. PM 2003.1.2223.320 (101150021).

This image depicts an *oiran*, or high-class courtesan, and her *kamuro* (young female attendant). The oiran wears a characteristic costume, intricate hairstyle, and high wooden clogs (*ni-ba geta*). Although the model here may well be an actual courtesan, the image appears especially contrived because shoes would not have been worn indoors.

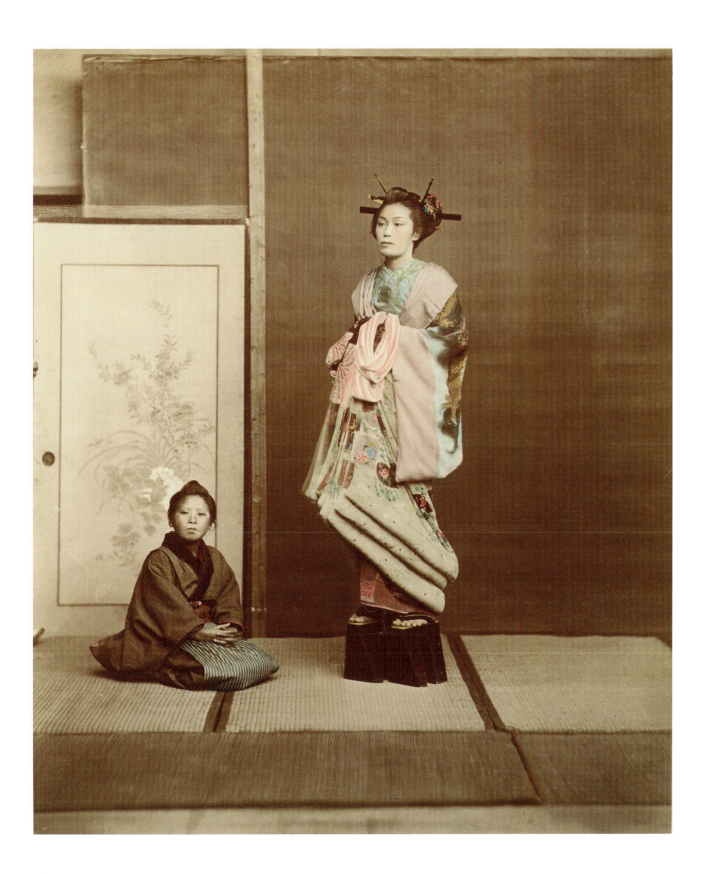

Man in samurai costume, 1870s. Studio of Stillfried & Andersen Co., Raimund von Stillfried, photographer. Hand-tinted albumen print, 23.6 × 19.2 cm (9¼ × 7½ in.). Collected by William S. Bigelow, 1880s. Gift of Mary Lothrop, 1927. PM 2003.1.2223.345 (96930003).

This image appears to depict a samurai warrior in ceremonial dress, with two swords. A hand-written caption in French reads "homme de cour" (courtier or court gentleman), but it is not known who wrote this or when it was written. Though clearly meant to represent a warrior, the portrait was made after the samurai class had already been disempowered, so the model is not an actual samurai but rather appears in costume. He wears a wig of the by-then forbidden hairstyle of the former warrior class and has theater-ready eyebrows. It is possible that the model was, in fact, an actor, rather than an unemployed (former) samurai. Compared with many other Stillfried portraits—including most of those in the Peabody Museum's collections—the background is uncharacteristically plain, although a limited number of other photographs also used a similar backdrop. The neutral background echoes the scientific style favored in physical anthropology in order to image human "types."

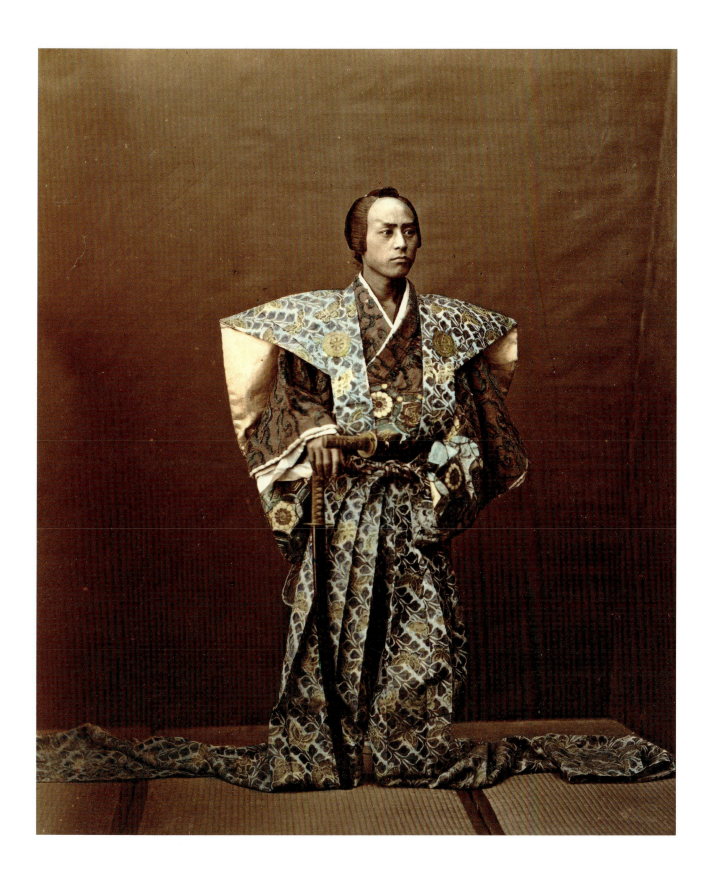

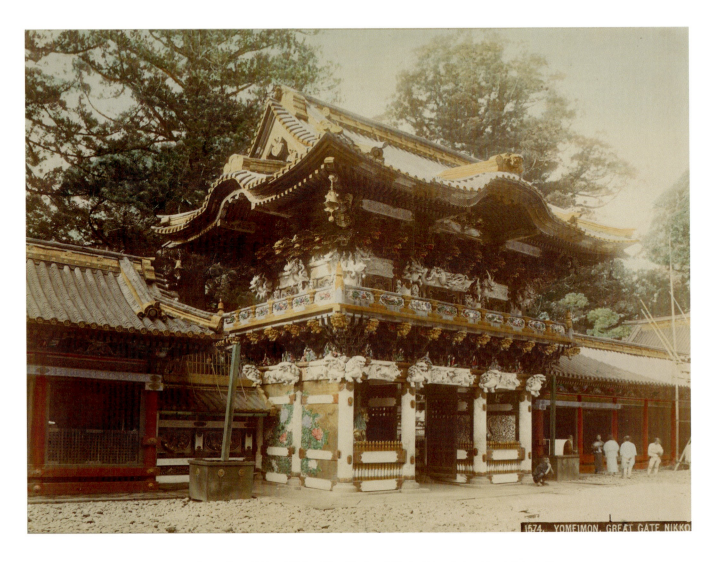

1674. YOMEIMON. GREAT GATE NIKKO

Yomeimon, Great Gate Nikko, 1880s−90s. Studio of Kimbei Kusakabe. Hand-tinted albumen print, 19.6 × 26.2 cm (7¾ × 10¼ in.). Collected by William A. Dunn. Gift of William A. Dunn, 1922. PM 2003.1.2223.280 (101150019).

The shrine and temple complex at Nikko, north of Tokyo, houses the mausoleums of several Tokugawa shoguns. Nikko was one of the first places outside Japan's treaty ports that foreigners were allowed to visit, and it became virtually a required stop for nineteenth-century tourists. Images of Nikko appear in nearly all souvenir albums of the period.

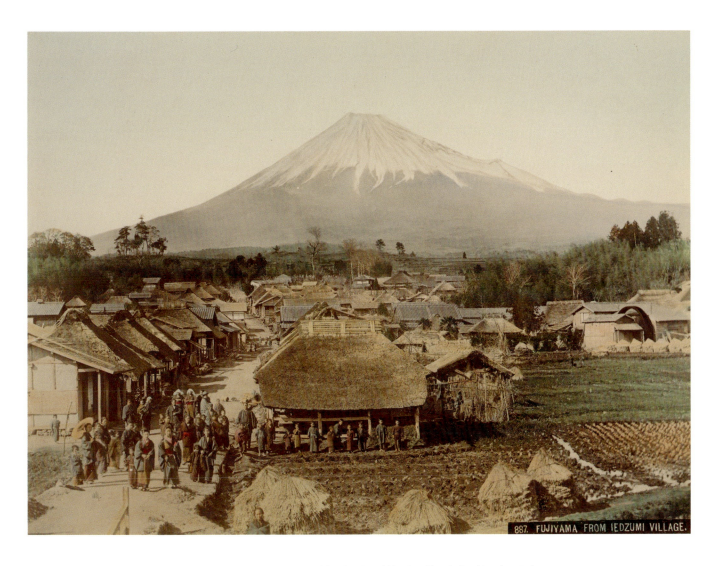

887. FUJIYAMA FROM IEDZUMI VILLAGE.

Fujiyama from Iedzumi Village, 1880s–90s. Studio of Kimbei Kusakabe. Hand-tinted albumen print, 19.8 × 26.2 cm (7¾ × 10¼ in.). Collected by George B. Gordon, 1898. Gift of George B. Gordon, 1898. PM 2003.1.2223.261 (101150015).

The sacred Mount Fuji was an important subject of Japanese visual representation prior to the advent of photography, and has been celebrated for many centuries in Japanese art, spanning the genres of ink painting, woodblock prints, and photography.

Colorist at work, 1880s–90s. Studio of Kimbei Kusakabe. Hand-tinted albumen print, 27.1 × 21.4 cm (10 $^5/_8$ × 8 $^3/_8$ in.). PM 2003.1.2223.390 (101150031).

This image depicts an artisan coloring a photograph. The popularity of hand-colored photographs as souvenirs among nineteenth-century tourists to Japan reflected an appreciation of the subtle use of watercolors and the skill of Japanese artisans, many of whom were initially trained in the ukiyo-e industry. The relative frequency with which images such as this are found in tourist albums of the time suggests that the artifice of the coloring process did not detract from the value of the photographs; on the contrary, purchasers paid a premium for colored photographs, and the craftsmanship associated with these painted images was recognized as an important part of their value.

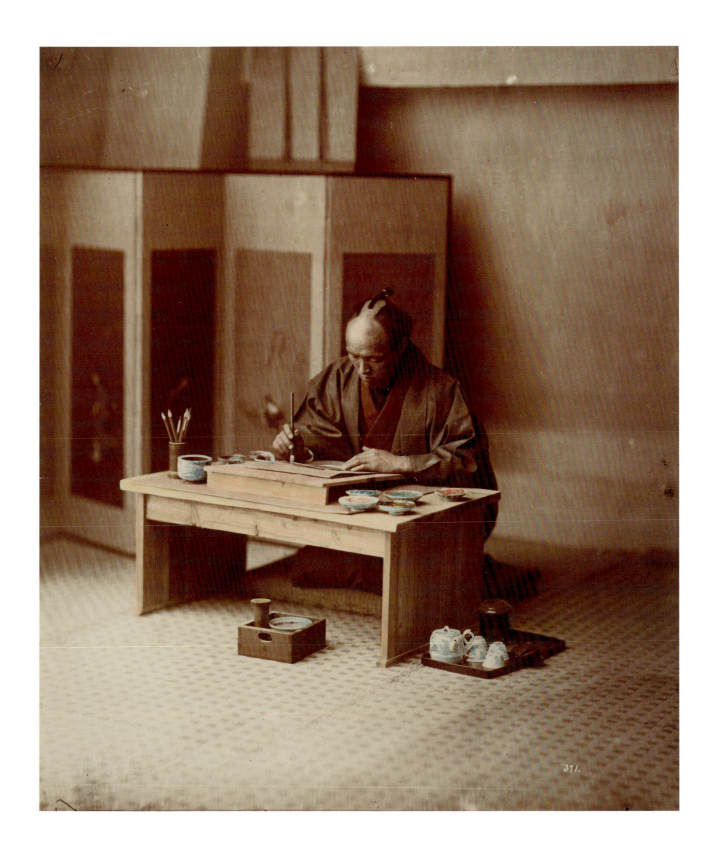

BENEATH THE SURFACE

The allure of these early Japanese photographs—as much for contemporary viewers as for nineteenth-century travelers—is due in large part to the seamless and seemingly innocent blend of artistic intervention (hand coloring and image composition, for example) with the intense illusion of reality inherent in the photographic image. The "exotic," captured on a smooth albumen surface, entreats us to believe in what the photograph tells us: about Japan, about the past, and about a distant place and time now lost. And it seems that very often we believe what we see: we believe that the image can stand on its own, by itself, without further explanation. When we gaze into the face of an attractive geisha dressed in silk kimono, do we question that she is what she appears to be?

It should come as no surprise, however, that things portrayed in tourist images are often not what they appear to be. The veracity of photographs has, of course, long been questioned, and tourist photographs in particular are well known to employ stereotypical representations of people and places, supplying the market with what it demands regardless of the lived realities of the subjects. Many of the Peabody Museum's photographs of Japan are carefully crafted and constructed images that both created and responded to viewers' preconceived notions of Japanese culture.

An example can be found in two prints of the same image, which depicts a laborer of some sort, probably a horse groom (*betto*), recognizable as such because he is dressed only in a loincloth and is marked by full-body tattoos (opposite). The two prints were made from the same negative (probably dating to the 1870s) in the Stillfried studio and were collected by William S. Bigelow in the 1880s. Today they are carefully archived in the museum's cold storage vault; they sit together in the same box, one on top of the other, separated by acid-free paper. It was because of this archival arrangement that I first noticed the differences between what initially appeared to be identical prints with virtually identical coloring. Finding it odd that Bigelow had purchased (inadvertently or intentionally?) and kept two prints of the same photograph, I compared them side-by-side.

On closer inspection, the prints proved to be significantly different, although there are some obvious consistencies between them. The tattoos on the right arm of the model, for example, appear to have the same underlying design in both prints. However, the body art was not merely colored differently, but was

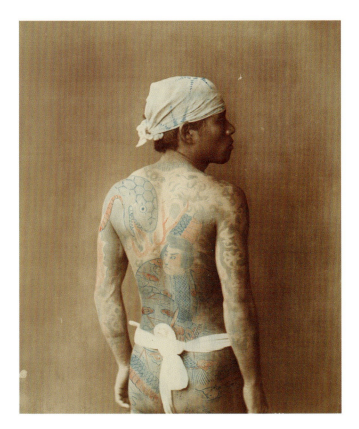 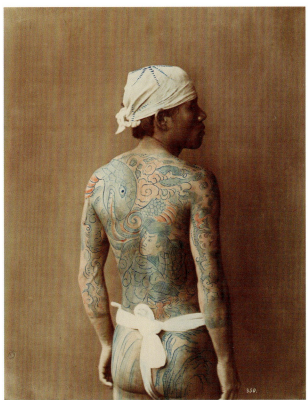

Tattooed man, 1870s. Studio of Stillfried & Andersen Co., Raimund von Stillfried, photographer. Hand-tinted albumen prints, *left:* 23.4 × 19 cm (9¼ × 7½ in.), *right:* 23.9 × 18.7 cm (9⅜ × 7⅜ in.). Collected by William S. Bigelow, 1880s. Gift of Mary Lothrop, 1927. PM 2003.1.2223.52 and .53 (101150009, 101150011).

Tattoos were used in Japan for centuries to mark lower-class occupations, criminality, and even outcast status. The government outlawed tattooing for Japanese citizens in 1872, although foreigners were permitted to get them. The subject of this image may have been at least partially tattooed (possibly on his upper right arm, for example), but the photograph was collected by William S. Bigelow in the 1880s, about a decade after the prohibition. On close examination, it seems that these "tattoos" were at least in part the creations of an artisan painting on the photographic print, rather than on the model's skin. There are distinct differences in the color selection and designs of the two images, especially on the model's lower body.

in fact not of the same design. This suggests that the colorists had a degree of artistic freedom in deciding the look of a full-body tattoo, in effect creating body art in the image where it did not actually exist on the physical body. Even the model's head scarf has been painted with different designs in the two prints.

Other photographs raise additional issues of presentation and interpretation. Although it may seem reasonable to conclude that two images of laborers (below), while posed, are in fact authentic portraits of working men, viewing them together reveals the photographer's artifice. The outdoor setting lends an air of naturalism and credibility to the photographs, but by comparing them one can quickly see that they feature the same model, attired for a different occupation in each. Images of people identified as working in specific occupations, such as horse grooms or teahouse waitresses, were popular tourist purchases, included in virtually all souvenir albums. One can only wonder how many of these were also made with professional models who portrayed the doctors, firefighters, "shampooers" (masseurs), and other characters. It is very likely that there were more examples of "staged authenticity" than portraits of working people performing their actual occupations for the camera.

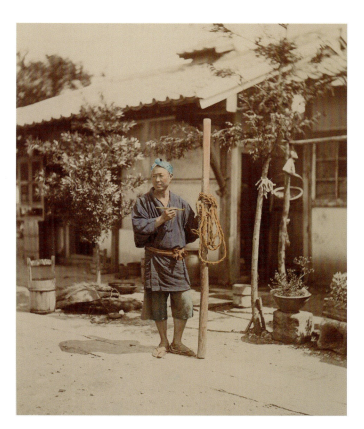 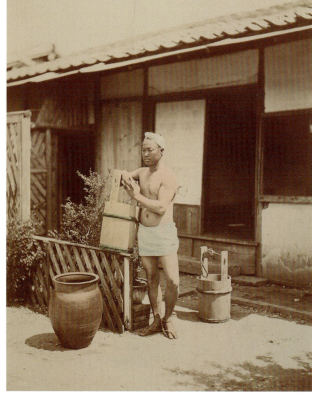

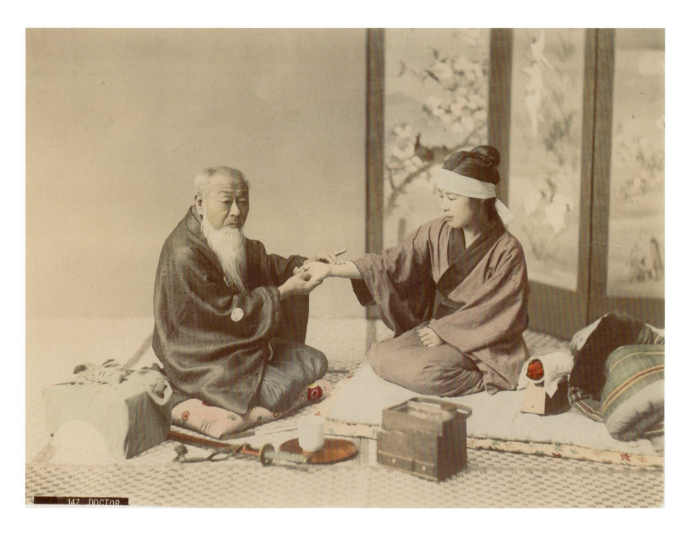

Doctor, 1880s. Studio of Kimbei Kusakabe. Hand-tinted albumen print, 19.5 × 26.2 cm (7 ⅝ × 10¼ in.). PM 2003.1.2223.13 (101160003).

There was clear commercial demand for images that illustrated various Japanese occupations, such as this photograph of a Japanese doctor. Variations on this image are commonplace in tourist albums of the period.

<small>OPPOSITE</small>

Laborers, 1870s. Studio of Stillfried & Andersen Co., Raimund von Stillfried, photographer. Hand-tinted albumen prints, *left:* 25 × 19.9 cm (9⅞ × 7⅞ in.), *right:* 23.6 × 20.2 cm (9¼ × 8 in.). Collected by William S. Bigelow, 1880s. Gift of Mary Lothrop, 1927. PM 2003.1.2223.25 and .26 (101150005, 101150007).

Souvenir photographs of this period often featured models who appeared in a variety of roles and in multiple images. This could reflect the difficulty of securing willing models or the perceived interchangeability of Japanese subjects in the eyes of Western consumers.

The constructed nature of tourist images can be discerned throughout the corpus of Japanese photographs at the Peabody. We know from the historical record that the samurai class was largely disenfranchised by the time tourists began to visit Japan in large numbers in the 1870s, yet these feudal warriors remained an enduring subject of the photographer's camera and the globe-trotter's album for decades after samurai themselves had disappeared from Japanese society. To Westerners fascinated with these symbols of Japan's martial heritage, samurai held the romantic appeal of the European knight, with whom samurai were often compared.

Photographs of "geisha" also reveal a gap between tourist fantasy and actual local experience. As I have already noted, Western visitors typically did not distinguish between geisha, who were hired by clients for their skills in the arts of music, dance, poetry, and urbane conversation, and sex workers, employed primarily or exclusively for sexual encounters (although sexual transactions with geisha did occur in some instances). Few foreign tourists had access to geisha, and when they mentioned "geisha" they were more than likely referring instead to prostitutes, who were easily available to them, or even teahouse waitresses. Ironically, many (but not all) of the women who portrayed geisha in early photographs were, in fact, prostitutes; studios otherwise had difficulty in procuring willing models to pose for them.[25]

A striking image from the Bigelow collection reflects these contradictions in the Western conception of the geisha (see p. 46). The model appears here in a carefully arranged composition that reveals the bare flesh of her upper chest; she seems to only just hold up her kimono, arms pressed close to her scarcely covered breasts. Interestingly, as Eleanor Hight notes in her discussion of this photograph, the model displays Western-style jewelry, perhaps a keepsake from a foreign client.[26] Hight also provocatively suggests that the photograph itself might have originally been a souvenir of a paid sexual encounter. Weak (or nonexistent) copyright protections meant that images originally created as private souvenirs were routinely sold commercially by the studios, so it is entirely possible that this photograph was privately commissioned, never intended to end up in another tourist's souvenir album, let alone an anthropology museum's archive.

Two men in samurai armor, 1870s. Studio of Stillfried & Andersen Co., Raimund von Stillfried, photographer. Hand-tinted albumen print, 23.6 × 19.1 cm (9 5/16 × 7 1/2 in.). Collected by William S. Bigelow, 1880s. Gift of Mary Lothrop, 1927. PM 2003.1.2223.364 (101150029).

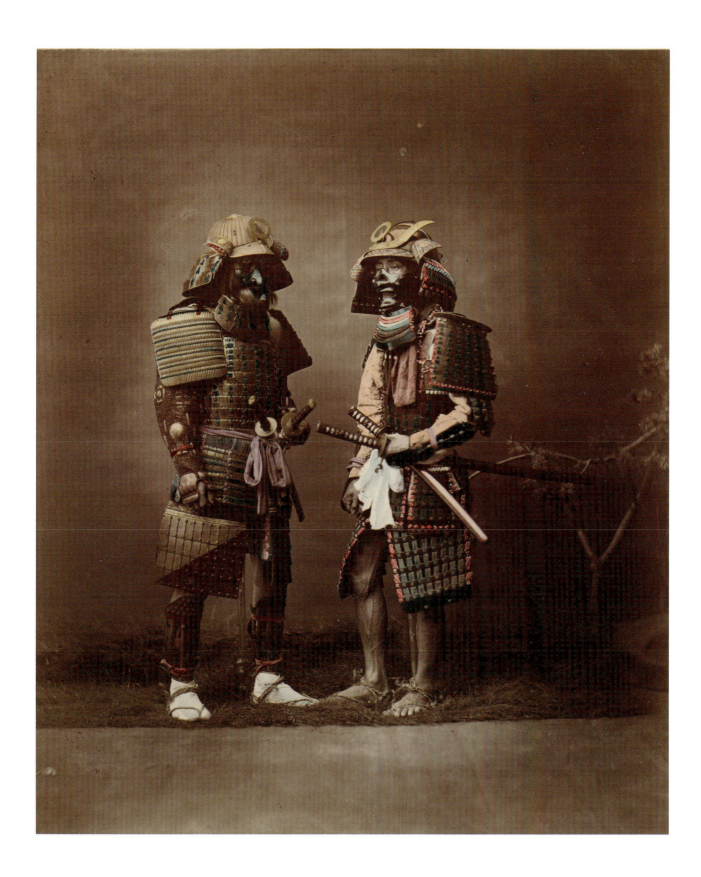

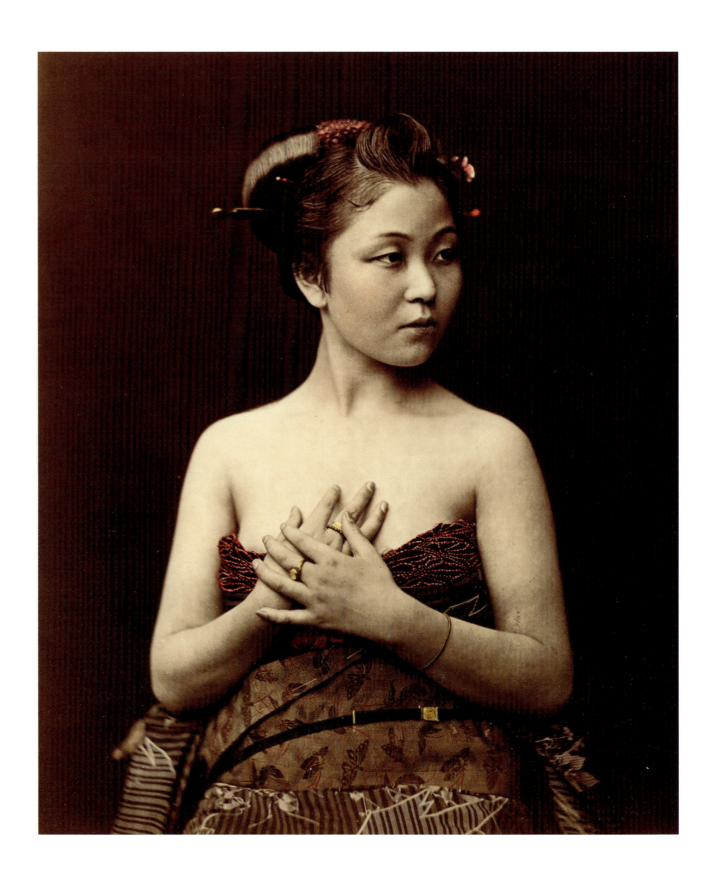

Whether created by foreign or Japanese photography studios, early photographs of Japan accompanied and precipitated visual journeys to both a real and an imagined Japan. No matter how quaint or stereotypical the images may appear to a viewer today, their carefully constructed compositions and the commercial nature of their production and circulation did not prevent them at the time from representing the "real" Japan to Western audiences. Neither, as we shall see, did this constructed nature prevent commercial photographs from becoming part of a scientific journey from Yokohama studios to Western archives.

Woman, 1870s. Studio of Stillfried & Andersen Co., Raimund von Stillfried, photographer. Hand-tinted albumen print, 23.4 × 19.2 cm (9 1/4 × 7 1/2 in.). Collected by William S. Bigelow, 1880s. Gift of Mary Lothrop, 1927. PM 2003.1.2223.296 (96810003).

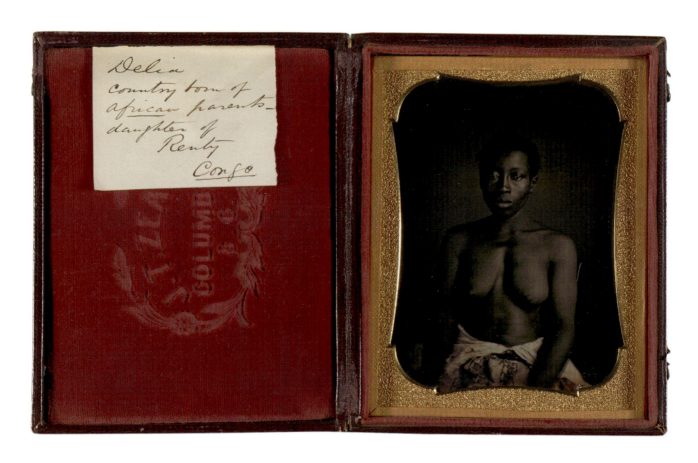

Delia, country born of African parents, daughter of Renty, Congo. Plantation of B. F. Taylor, Esq., 1850. Joseph T. Zealy, photographer. Commissioned by Louis Agassiz. Daguerreotype in velvet-lined leather case (closed), 11.9 × 9.7 × 2.1 cm (4⅝ × 3¾ × ¾ in.). Transfer from the Museum of Comparative Zoology, Harvard University, 1935. PM 35-5-10/53040 (101250004).

CHAPTER 3

Vanishing Types

*The only thing I don't like in your letter is the confession that you are
still frittering away your valuable time on the lower forms of animal
life, which anybody can attend to, instead of devoting it to the
highest, about the manners and customs of which no one is so well
qualified to speak as you. Honestly now, isn't a Japanese a higher
organism than a worm? Drop your damned Brachiopods. They'll
always be there and will inevitably be taken care of by somebody or
other as the years go by, and remember that the Japanese organisms
which you and I knew familiarly forty years ago are vanishing types,
many of which have already disappeared completely from the face of
the earth and that men of our age are literally the last people who
have seen these organisms alive. For the next generation the Japanese
we knew so well will be as extinct as Belemnites.*

—William Sturgis Bigelow to Edward Sylvester Morse[27]

The language of this 1913 letter from Bigelow, the great collector of Japa-
nese art, to Morse, the renowned zoologist and cultural authority on Japan,
may strike contemporary readers as more than a little paternalistic. Given
Bigelow's admiration for the Japanese people, however, one can assume that he
was using good-natured hyperbole in his comparison of people to worms in
order to persuade Morse to publish an account of his life in Japan. Morse was
an influential figure in late nineteenth- and early twentieth-century Western
understandings of Japan, and his lectures in Boston in 1879 had inspired the
interest of Bigelow—and a host of other notable Bostonians—in Japan.[28]

Bigelow framed his friendly rebuke to Morse in the language of zoology and biology, and it is perhaps tempting to see this communication between the two men as a reflection of their shared background in science. But Bigelow's mention of the "type" in his letter references far more than academic training and a scientific orientation: it reflects the wider saturation of popular late nineteenth- and early twentieth-century Western discourses on categorizing humans with scientized notions about the relationship between physical bodies and intellectual and moral qualities, particularly of non-Western "others."

Bigelow's letter illustrates three components of this scientized popular discourse. The first is the idea that human beings could be divided into distinct "types" that exhibited varying degrees of civilization, intelligence, morality, and the like. The second is that some of these types were in danger of disappearing—"vanishing"— in the onslaught of colonial contact with the "superior" cultures from the Western world. The third component is the notion that, prior to total extinction, certain types could and should be saved, or "salvaged." This salvaging was to be done by means of textual or visual documentation, as well as by collecting objects of material culture—even if the native peoples who created the objects in the first place were themselves (thought to be) doomed to extinction.

By examining how these ideas were (or were not) applied in the Japanese case and how types came to be understood as being in danger of vanishing, we can place Bigelow's collection of photographs of and ideas about Japan in historical context and provide a framework for understanding how his and other souvenir photographs eventually made their way into the archives of an anthropology museum.

The Vanishing Type

As Elizabeth Edwards has established, the concept of the type was "one of the most important elements in nineteenth-century anthropological analysis."[29] Taking their cue from scientists working in biology and related fields, early anthropologists such as Lewis Henry Morgan and E. B. Tylor attempted to classify and quantify human beings and locate them within an evolutionary framework along a posited great chain of human progress. The concept of type was used to understand racial and cultural diversity, with culture itself generally understood as being biologically determined. Comparative data concerning types was collected in order to aid in this understanding of humankind. Newer anthropological systems were built on preexisting typologies and systems of human clas-

sification: Linnaeus's *Systema Naturae* (1735), for example, created a taxonomy of humans based in part on such criteria as skin color and head shape.[30]

Simply put, anthropologists used "type" to refer to a set of standard characteristics and qualities that distinguished a given group, as well as to denote a person or thing exhibiting these characteristics and qualities. Individuals could be identified as exemplifying particular physical traits such as hair texture, height, or skin color, and could be classified further as possessing certain moral or cultural qualities, including fierceness, wanton sexuality, varying degrees of savagery/civilization, and the like. The physical, moral, and cultural could then be tied together, and an individual with particular characteristics could be used as a kind of standard-bearer for a racial, occupational, or other type.

Nineteenth-century anthropology generally held that "type" established the parameters of "race," and intellectual and political developments at the time enabled the abstract concept of "racial type" to be regarded as something concrete.[31] By the middle of the century, anthropology had greatly contributed to the idea of race as a fixed, natural category. This allowed different "types" of people to be ranked in a hierarchy of development, with the "Caucasian," upper-class, Anglo-Saxon male invariably placed at the apex, and the "Negro" or Australian Aborigine often placed at the bottom.

This system fit neatly into—and simultaneously supported—the colonial worldview engendered by European and American expansion across the globe. It was a widely accepted notion that colonized peoples were in danger of being overwhelmed by colonial cultures, which brought with them various aspects of Western societies ranging from advanced technologies to diseases. As a result, non-Europeans were thought to be in danger of vanishing off the face of the earth. Much more could be said about the historical antecedents, development, and later demise of notions of the type (in most social sciences, at any rate), but for the purposes of understanding the Peabody Museum's early photographs of Japan, it is useful to review the ways in which these notions played out specifically in the realm of photography.

PHOTOGRAPHING THE TYPE

One of the earliest examples of human type photography produced within a scientific context is found in the Peabody Museum's archives, in a collection of daguerreotypes created in the 1850s for the Swiss-born naturalist and Harvard University professor Louis Agassiz (1807–1873). The collection of thirty-six

photographs, known primarily for its fifteen images of enslaved individuals from South Carolina plantations, also includes images of Chinese, Native American, and Hindu subjects.[32] These photographs were produced as visual evidence in support of Agassiz's polygenist theories, which posited human beings as divisible into separate "races," each comprising a separate species emanating from a distinct and separate creation.[33] Polygenesis was highly controversial, opposed not only by Darwinists but also by many Christians, who objected to the notion of multiple creations, which they saw as a contradiction to biblical truth.

At the time the daguerreotypes were produced, anthropology itself was not yet a formalized academic discipline and photography was a revolutionary new technology that required specialized knowledge and skills. The daguerreotype process was publicly introduced to the world only in 1839, and it is significant, then, that in this early project we see the beginnings of a visual language of science in which the supposedly objective and realist technology of photography recorded the visible markers of "type." Agassiz's physical examinations of enslaved individuals in South Carolina convinced him that there was indeed typological diversity among the different tribes and groups from Africa represented in his small sample, and he commissioned the photographs to record his data. Agassiz directed the project; his colleague Robert W. Gibbes (1809–1866), a physician and paleontologist in Columbia, South Carolina, oversaw production of the daguerreotypes; and in 1850 Columbia society photographer Joseph T. Zealy (1812–1893) produced the photographs of the subjects.

The bourgeois conventions of the era's commercial portrait photography remained largely intact in Agassiz's scientific commission: the daguerreotypes' gilded frames and velvet-lined leather cases as well as the studio furniture and rugs in the images were typical for the studio's normal commercial market of paying customers. In this context, however, they present an especially jarring juxtaposition with the images of the seven enslaved individuals, who are shown naked and seminaked, exposed to the scientist's scrutiny and literally stripped of the social and personal contexts that their clothing might otherwise have provided. The men and women were photographed in at least two poses, including full-length and torso shots, and frontal, rear, and profile views, against neutral backgrounds. It is possible that additional photographs in other poses were made but have not survived in the museum's collection. The ways in which the body is arranged in each image make salient Agassiz's scientific intent and

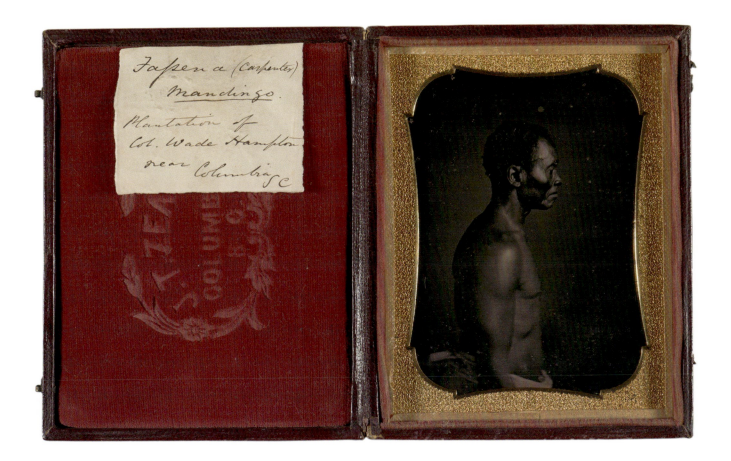

Fassena (carpenter), Mandingo. Plantation of Col. Wade Hampton, near Columbia, S.C., 1850.
Joseph T. Zealy, photographer. Commissioned by Louis Agassiz. Daguerreotype in velvet-lined
leather case (closed), 11.9 × 9.7 × 2.1 cm (4⁵/₈ × 3³/₄ × ³/₄ in.). Transfer from the Museum of
Comparative Zoology, Harvard University, 1935. PM 35-5-10/53051 (101250015).

represent a technique that would be echoed in future type photography, even if
the velvet and gilt trappings might confuse the situation for viewers today.

The commingling of the bourgeois style of presentation and the practice of
photographing enslaved individuals for scientific study underscores the cruel
circumstances of those pictured and makes these images particularly painful
to view. Without knowledge of the wider context of how the photographs were
made, the images do not speak to the viewer obviously or fully about the

brutality of the situation that allowed for these particular photographic encounters. Despite the elegant trappings, however, one can easily see that these were intended to be images of specimens, not portraits of individual human beings. Many of the subjects were identified by name and also by tribe or ethnic group (see p. 53), which might at first seem to be at odds with a project that turned people into objects of scientific study rather than individuals valued for their full range of human qualities. Indeed, later photographic type studies by scientists, colonial administrators, and others with a personal or professional interest in studying native bodies would mostly—though not entirely—eliminate the subjects' names in favor of generalized descriptions in which an individual came to stand for an entire group (see image, opposite).

Agassiz's careful labeling, however, was in fact clearly in line with his research agenda. He wanted to use photographs to demonstrate the typological variation within enslaved (i.e., African) populations. The labeling of individuals (and identifying their tribal affiliations) would ostensibly aid in this project by showing how distinct each type was because, Agassiz believed, the photographs demonstrated that his subjects were so evidently different from each other visually. Notwithstanding the critical question of accuracy—for we have no way to verify whether or not the names and tribes of origin listed on the labels were in fact correct or, as is possible, were arbitrarily imposed by slave owners—the attention to detail here reflects Agassiz's application of scientific method to this emerging form of data collecting.

In contrast, the racial type images of Chinese, Native American, and Hindu subjects also commissioned by Agassiz were composed differently from those of the enslaved African subjects. Their makers, including Lorenzo G. Chase (active 1844–1856) of Boston, Frederick and William Langenheim (1809–1879 and 1807–1874) of Philadelphia, and E. T. Whitney (1820–1893) of Rochester, New York, were, like Zealy, prominent commercial photographers. However, although they employed the same technology and the same style of studio furnishings as those seen in Zealy's images, all the nonenslaved subjects (with the

Fijian type male, 1890s. Attributed to John Waters. Albumen print on paperboard mount. Print: 19.5 × 13.8 cm (7³⁄₄ × 5³⁄₈ in.). Collected by Alexander Agassiz, 1897–98 or 1899–1900. Transfer from the Museum of Comparative Zoology, Harvard University. PM 2004.29.21839 (99040084).

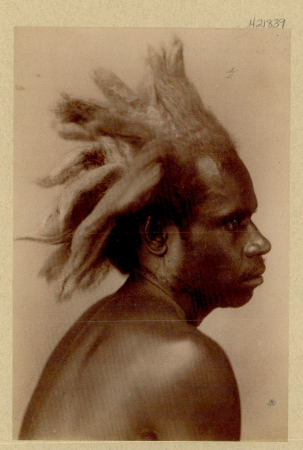

Fijian type - male

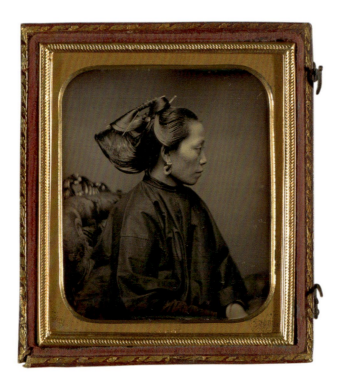

Lum Akum, c. 1844–56. Lorenzo G. Chase, photographer. Commissioned by Louis Agassiz. Daguerreotype in velvet-lined leather case (closed), 9.4 × 8.5 × 2 cm (3 ⅝ × 3 ⅜ × ¾ in.). Transfer from the Museum of Comparative Zoology, Harvard University, 1935. PM 35-5-10/53056 (101250021).

The subject in this image has been identified as a Chinese woman named Lum Akum.

exception of one Native American man) were photographed fully clothed. The process was less intrusive than with the enslaved subjects: they were photographed under essentially the same studio conditions as paying customers would have been, with the same furniture, props, and backgrounds. Nevertheless, these subjects were also shown in frontal and profile views, as the developing standard for scientific imaging required, making the scientific purpose of the images clear.

Image composition is significant because it can offer clues about a photograph's intended use, among other things, but it does not determine an image's

Vanishing Types

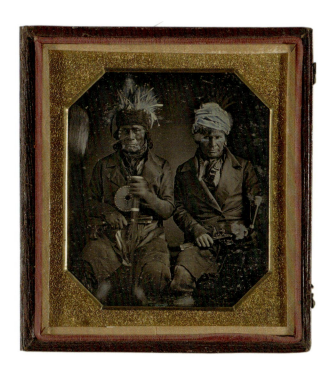

To?h min ne, A Brave, and White Pigeon, c. 1844–55. Lorenzo G. Chase, photographer. Commissioned by Louis Agassiz. Daguerreotype in velvet-lined leather case. Plate: 8.9 × 7.6 cm (3½ × 3 in.). Transfer from the Museum of Comparative Zoology, Harvard University, 1935. PM 35-5-10/53067 (101250028).

The men in this image are named in a caption as "To?h min ne, A Brave," at left, and "White Pigeon," on the right. The men are dressed in Western-style suits, and both hold pistols.

meaning. In this case, it merely set the stage for future meaning creation. For example, Agassiz used his photographs to illustrate his lectures on racial differences among Africans.[34] They ultimately became scientific through the context of their use rather than purely through the circumstances of their production, the posing of the subjects, or even his original intentions for the project. I will return to this point later, for it has important implications in the context of Japanese photographs.

Agassiz's slave and nonslave daguerreotypes were first accessioned into the collections of Harvard's Museum of Comparative Zoology, which he founded in

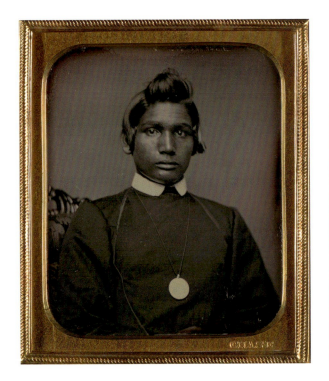
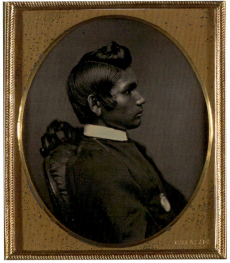

Hindu, c. 1840–55. Lorenzo G. Chase, photographer. Commissioned by Louis Agassiz. Daguerreotypes in velvet-lined cases. Plates: *left:* 9.2 × 8 cm (3⅝ × 3⅛ in.), *right:* 7 × 5.7 cm (2¾ × 2¼ in.). Transfer from the Museum of Comparative Zoology, Harvard University, 1935. PM 35-5-10/53052 and 35-5-10/53063 (101290016, 101290027).

Photographing the same subject in different profiles can be a transformative act. These two images show the same individual, captioned as "Hindu," seated in a carved wooden chair with elaborate upholstery and posed against a neutral backdrop. Either image considered individually might serve equally well as an example of mid-nineteenth-century portraiture, but together they fulfill scientific expectations for frontal and profile views of a "specimen."

1859, before they were transferred to the Peabody Museum. These photographs have traveled a scientific path from the moment they were produced in the 1850s until the present day. It is significant that their path led from a museum of natural history, where non-Western "others" were considered appropriate research subjects alongside zoological, mineral, and botanical specimens, to an anthropology museum, which was at least concerned with the study of human beings.

Anthropometric Photographs

Type photography came into increasing prominence in the several decades following Agassiz's pioneering daguerreotype project. As anthropology began to emerge as an organized scientific discipline in universities and learned societies in the 1860s and 1870s, scientific type photography began to develop. Although there was no single version of scientific type photographs, type images used for anthropological research commonly featured naked or nearly naked bodies in profile and frontal views, with the visible body purportedly manifesting signs of intangible qualities such as intelligence and culture.

Anthropometric photographs were a form of photography produced with specifically scientific intentions under newly developed methodologies. They were made in a prescribed manner, with the goal of objectively measuring physical characteristics for the purposes of racial classification and categorization. Two anthropometric methods for photography were promulgated separately in the late 1860s and early 1870s by Britons John Lamprey, a librarian at the Royal Geographic Society and officer at the Ethnological Society of London, and Thomas Henry Huxley, the biologist known as "Darwin's bulldog" for his ferocious advocacy of Darwin's theory of evolution. Both systems were developed with the aim of collecting scientific data to enable anthropologists to make "objective" cross-racial comparisons. Lamprey's methodology resulted in photographs that echoed Agassiz's images, specifying that subjects be photographed unclothed in both frontal and profile poses. Lamprey's innovation was to photograph subjects against a "normalizing" grid, a background of two-inch-square threads forming a mesh within a 3-x-7-foot frame.

Huxley's method similarly called for photographing naked subjects in frontal and side views, but further stipulated the use of stabilizing and measuring rods to steady the subject and provide scale. Although both methods were ultimately discredited within anthropology, Lamprey's system in particular had a significant impact on anthropological photography until the end of the nineteenth century. In 1869 Lamprey's system was published in the "Ethnological Notes and Queries" section of the *Journal of the Ethnological Society* as "On a method of measuring the Human Form, for the use of Students in Ethnology."[35] Huxley's more cumbersome method was not published.

Both methods were inherently connected to British imperial power in the last decades of the nineteenth century, when colonial subjects were forced to undergo multiple forms of scrutiny and surveillance, including photographic

documentation.[36] This is important to understand, because these anthropo-metric systems were so invasive and dehumanizing as to essentially require the power of the state in order to be put into practice. In fact, the systems were not easily executable even under colonial regimes, and they succeeded only in places where the power of colonial authorities was virtually total, such as prisons and hospitals.[37]

"Historic Boards" in the Peabody Museum

One of the first museums of anthropology and among the earliest to collect pho-tographs, the Peabody contains one of the world's foremost archives of early anthropological photographs. Many of the earliest of these were archived by being attached to what have come to be referred to within the museum as "His-toric Boards," pieces of paperboard on which photographs (of human types, ethnographic and archaeological objects, and natural environments) acquired by the museum were mounted to keep them flat and allow for convenient filing.

Storing photographs in this manner was a common practice in many muse-ums in the first half of the twentieth century. The Peabody's Historic Boards were consulted by curators, faculty, and students in their anthropological research and study. Over ten thousand boards containing more than twenty-five thousand individual prints were created from about 1930 to 1960 at the museum. Captions indicating the subject's geographic or cultural affiliation—and sometimes the museum number, collector's name, photographer's name, and other pertinent information—were written or typed on the board itself. The borders of some photographs were trimmed to fit the board, which in turn had been sized to fit in a filing cabinet; valuable contextual information, includ-ing the names of photographers and original captions, was sometimes lost as a result of this practice, which has long since been abandoned.

Type images archived on Historic Boards reflect the early anthropological interest in the body as a visible indicator of "racial" and cultural qualities, and the photograph as an objective document of these qualities. The collections

Australian Aboriginal woman and man with kangaroo carcass, c. 1873. John William Lindt. Albumen print on paperboard mount. Print: 19.7 × 14.9 cm (7 3/4 × 5 7/8 in.); mount: 30.4 × 25.6 cm (12 × 10 in.). PM 2004.29.21713 (99040085).

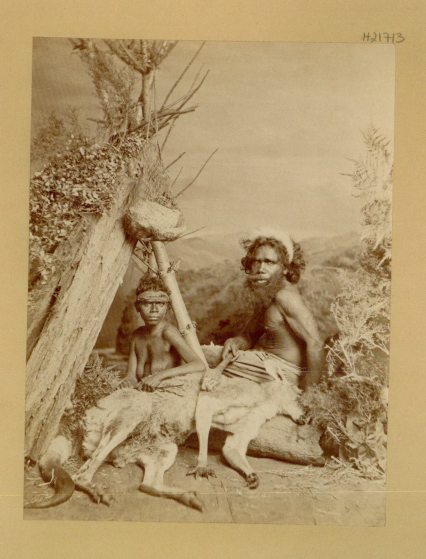

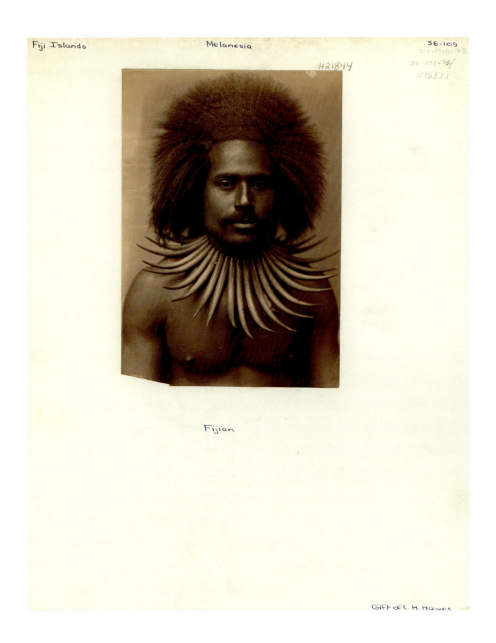

Fijian

Fijian, 1890s. John Waters, photographer. Albumen print on paperboard mount. Print: 19.5 × 13.8 cm (7 ⅝ × 5 ⅜ in.); mount: 35.5 × 27.9 cm (14 × 11 in.). Collected by Charles Henry Hawes, 1901. Gift of C. H. Hawes, 1936. PM 36-109-70/10868.1.1 (99040083).

This native type image of a Fijian man was given to the Peabody Museum in 1936 as part of a collection of over 200 prints of subjects from around the world. Another copy of this photograph was collected by Alexander Agassiz and given to the museum in 1899. As is the case in the Japanese collection, the model shown here appeared in multiple commercial images depicting Fijian types and cultural scenes.

record the museum's deep engagement with indigenous peoples of North and Central America in ethnographic and archaeological projects. There are also collections representing expeditions sponsored by the museum or undertaken by other anthropologists in many other parts of the world, where photographs were used to document physical types, specific cultural, agricultural, and other practices, and objects of material culture.

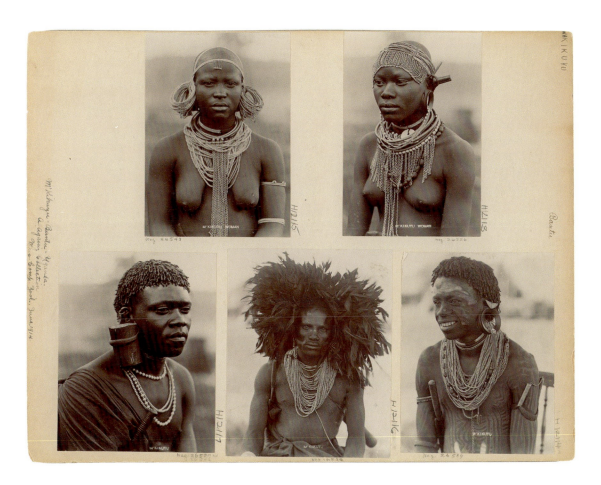

Kikuyu, Bantu, c. 1900−1908. Photographer unknown. Albumen prints on paperboard mount. Prints: 13.2 × 9 cm (5¼ × 3½ in.) each; mount: 27.8 × 35.4 cm (11 × 14 in.). Collected by Alexander Agassiz. Transfer from the Museum of Comparative Zoology, 1914. PM 2004.29.12113−.12117 (101160026).

Additional classificatory inscriptions on the mount for these photographs read "M'Kikuyu−Bantu−Uganda."

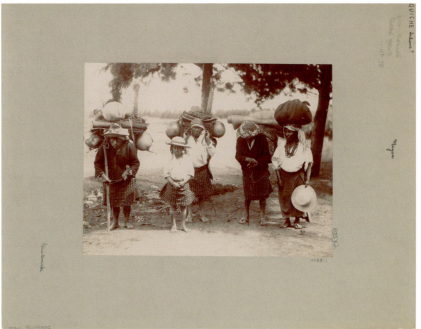

Don Carlos Madrid and bodyguards in front of Stela A, Copán, Honduras, December 21, 1891. Photographer unknown. Glass-plate negative, 20.3 × 25.4 cm (8 × 10 in.). PM 2004.24.211 (130130018).

Quiche Indians?, Mayan, Guatemala, c. 1900. Photographer unknown. Albumen print on paperboard mount. Print: 16.4 × 21 cm (6 3/8 × 8 1/4 in.); mount: 28 × 35.6 cm (11 × 14 in.). Gift of George B. Gordon, 1901. PM 2004.29.8582 (101160024).

H23668

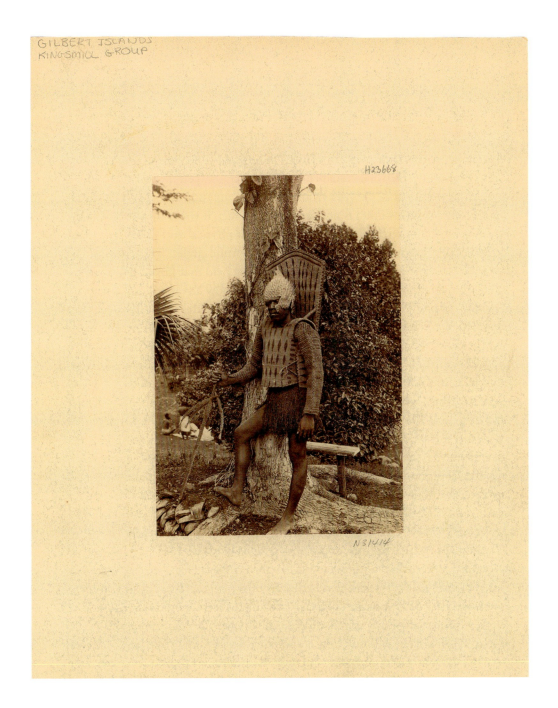

N31414

Kiribati warrior in armor, with helmet made of porcupine fish skin, 1890s. Photographer unknown. Albumen print on paperboard mount. Print: 12.7 × 10.2 cm (5 × 4 in.).
Mount: 35.6 × 28 cm (14 × 11 in.). PM 2004.29.23668 (99040082).

This photograph was made in what is today called the Republic of Kiribati, on one of the central Pacific islands known under British rule as the Gilbert Islands.

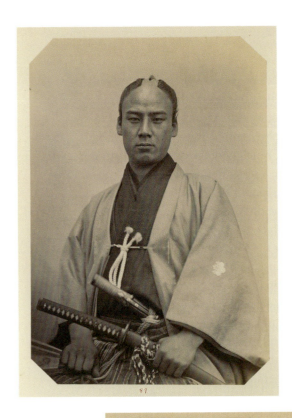 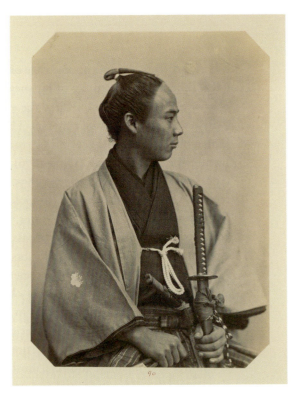

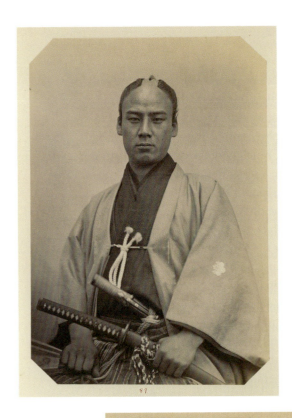

> Collection anthropologique du Muséum de Paris.
>
> 204. Toa - matsou Ta - rō (23 ans) né à Yédo
> 2° Serviteur et parent du 2° ambassadeur du
> Taïcoune du Japon à Paris.
> Phot. en 1864.

Nishi-Kitsi or Toa-matsu, 23 years old, 1864. Jacques-Philippe Potteau. Albumen prints mounted on paper in leather-bound album. Prints: 19.7 × 14 cm (7 3/4 × 5 1/2 in.) each; pages: 33 × 25.4 cm (13 × 10 in.) each. Gift of Alexander Agassiz, 1910. Courtesy of Tozzer Library, Harvard University.

These portraits are from the first volume in Jacques-Philippe Potteau's *Collection Anthropologique du Muséum de Paris,* created for the Muséum d'histoire naturelle. Several other photographers contributed to the series, including Louis Rousseau, Pierre-Joseph Rossier, and Paul-Émile Miot. Images were numbered in pencil to correspond to a handwritten caption list tipped into the front of each album. Identifying information was printed on labels attached to versos of image mounts.

Ernest II, Duke of Saxe-Coburg and Gotha. One page shows Japanese racial types in half-length format, in both frontal and profile studies, photographed in front of a neutral backdrop (see p. 70).[42] The use of this format clearly indicates anthropological intention, as it conforms to emerging contemporary standards of scientific photography, and the subjects are a rare example of non-Ainu Japanese individuals photographed specifically for a scientific project.

The album's photographs were either taken from life or collected from various commercial and scientific sources and reproduced. In 1870 Dammann received commissions from the Berliner Gesellschaft für Anthropologie, Ethnologie und Urgeschichte to produce ethnographic portraits. Demand for these photographs from museums and universities prompted a larger project, also supported by the Berlin Society, to provide a more comprehensive collection of photographs for scientific study. After Carl Dammann's death, his half brother (or possibly cousin) Frederick completed the work.

Apart from the Dammann album and possibly a few other sets of images, early scientific type photography of Japanese subjects was overwhelmingly focused on the Ainu, one of the indigenous peoples of northern Japan, who were considered by most scientists at the time to be "racially" distinct from the Japanese. In conjunction with questions about the origins of the Japanese people, debates raged in nineteenth- and early twentieth-century Japanese and foreign anthropological circles about whether the Ainu were the remnants of a proto-Japanese type, a non-Japanese indigenous group that had been overpowered by prehistorical Japanese, or even, perhaps, descendants of a "lost tribe" of Caucasians. Current thinking, based on DNA evidence and continuing archaeological and other scholarship, considers the Ainu people to be descended from the ancient Jomon (14,000–300 BCE) people of Japan, and thus indigenous to the archipelago but ethnically distinct from the Japanese. It was only in 2008, however, that the Ainu people were officially recognized by the Japanese government as indigenous people, just prior to Japan's hosting of a G8 Summit in Hokkaido.

The Ainu were the only group in Japan to have been consistently the subject of both tourist and scientific photography in the nineteenth century. The photographs appeared in travelogues and tourist albums as well as in scientific studies in anthropology, medicine, and other fields. These images often fostered already widely held views that the Ainu were Japan's version of the American Indian: their "vanishing race" or "noble savage." Visible Ainu cultural practices such as tattooing and body adornment, as well as aspects of their physiognomy such as eye shape and body hair, were repeatedly photographed and discussed in

Japan, c. 1870. Carl Dammann. Albumen prints on paperboard mount. Prints: approx. 19.7 × 13.3 cm (7 3/4 × 5 1/2 in.) each; overall: 48 × 64 cm (18 7/8 × 25 1/8 in.). Gift of Alexander Agassiz to the Harvard Museum of Comparative Zoology. Transfer to the Library of the Peabody Museum of American Archaeology and Ethnology, 1902. Courtesy of Tozzer Library, Harvard University.

This page of type photographs of Japanese subjects — a troupe of acrobats visiting Paris — was published in *Anthropologisch-Ethnologisches Album in Photographien* (1874; see pp. 67, 69).

scientific and travel literature as evidence of the "primitive" state of their culture. Both male and female Ainu were almost always pictured in traditional clothing, rather than in the Japanese or Western-style clothing that would have been encouraged or even required (by Japanese decree) in some Ainu communities.

Indeed, as an indigenous group with a long history of unequal economic and political relations with the Japanese feudal domains, national government, and settlers, the Ainu fulfilled an ideological function in Japanese society that closely paralleled that of Native Americans in American society. The Ainu were considered less developed than the Japanese, and in need of "civilizing"— their perceived savagery being considered a detriment to the Japanese nation, however convenient it had proved to be for the government's extraction of Ainu labor and of natural resources from Ainu lands. In fact, American consultants like US Secretary of Agriculture Horace Capron, who served under Presidents Andrew Johnson and Ulysses S. Grant, were employed by the Japanese government in the late nineteenth century to advise them on how to "develop" the former Ainu lands in the northern island of Hokkaido and handle the "Ainu problem."[43] In 1851, following the Mexican-American War, Capron had served the US government in Texas, charged with forcibly relocating various Native American tribes.[44]

For many centuries prior to the advent of photography, visual imaging had been used to establish and reinforce the "otherness" of the Ainu, depicting them as exotic and savage for a local Japanese audience. The photographing of Ainu subjects and the circulation and consumption of the resulting images had a visual precedent in the *Ainu-e*, paintings of Ainu people by Japanese artists from as early as the twelfth and thirteenth centuries. These often portrayed the Ainu as barbarous and uncivilized, visually absorbing the subjects into the wider Japanese discourse that valued the Ainu as a collective source of labor who could provide cheap access to the rich natural resources of their homeland, rather than as fully entitled human beings. By the nineteenth century, painted portraits of Ainu people invariably exaggerated physical characteristics such as hairiness and strength.[45] In the second half of the nineteenth century, as photography became available to scientists and, later, to private travelers, photographs replaced these earlier visual representations.

Photographic images both reflected and helped create scientific discourses about the Ainu. Images ostensibly proved the group's status as "inferior" (to the Japanese) by marking them as primitive and different based on clothing, body modification and adornment, dental features, eye shape, and amount of body

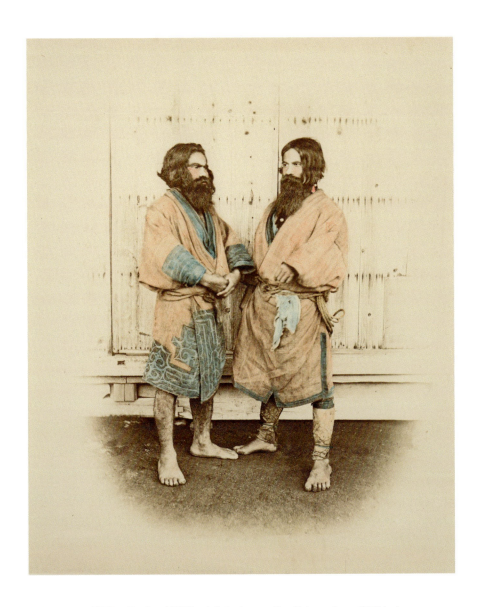

Two Ainu men, 1870s. Studio of Stillfired & Andersen Co., Raimund von Stillfried, photographer. Hand-tinted albumen print, 23.1 × 18.8 cm (9¹⁄₈ × 7³⁄₈ in.). Collected by William S. Bigelow, 1880s. Gift of Mary Lothrop, 1927. PM 2003.1.2223.417 (101420019).

Much of the imagery produced of male Ainu subjects ostensibly provided visual evidence of the stereotype of Ainu people as hirsute (but see opposite, left). Both subjects in this image have long hair and full beards, and the man on the left has hairy legs. The man on the right wears salmon skin leggings, and both wear elm bark cloth garments with characteristic design. Such clothing was widely acquired by Western collectors and museums. The Peabody Museum stewards an extensive early collection of Ainu clothing. The oval vignetting of the image suggests a link between the work of Raimund von Stillfried and Felice Beato, with whom Stillfried trained during his early career in Japan (see pp. 24, 76).

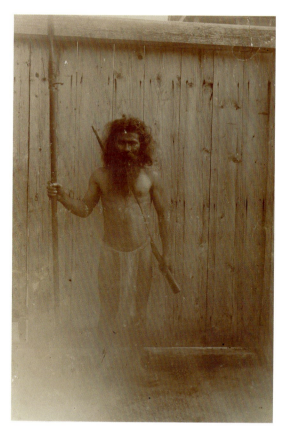

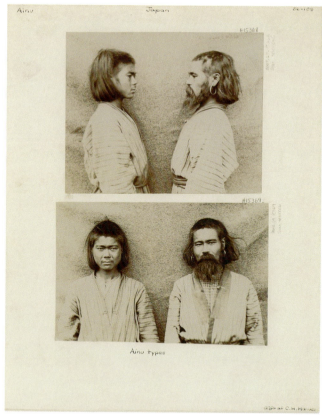

Physical type portrait of Ainu man, 1901. A. von Friken or Charles Henry Hawes, photographer. Albumen print, 20.3 × 12.7 cm (8 × 5 in.). Gift of C. H. Hawes, 1936. PM 2004.29.15372 (98450011).

The handwritten caption states, "Showing that the popular idea of the hirsute Ainu is false." Photographs were used as evidence both in support of and against this idea.

RIGHT

Ainu Types, 1901. A. von Friken or Charles Henry Hawes. Albumen prints on paperboard mount. Prints: *top:* 14 × 17.8 cm (5½ × 7 in.); *bottom:* 14.6 × 18.4 cm (5¾ × 7¼ in.); mount: 35.5 × 27.9 cm (14 × 11 in.). Gift of C. H. Hawes, 1936. PM 2004.29.15368–.15369 (101160017).

These photographs were made either by A. von Friken, inspector of agriculture for the Russian government on the island of Sakhalin, or by the Cambridge-educated British anthropologist, traveler, and writer Charles Henry Hawes (1867–1943). Hawes published an illustrated account of his 1901 travels in Japan, Korea, Manchuria, Sakhalin, and Siberia as *In the Uttermost East* in 1904, and these and other images that he gave to the Peabody were produced during these travels, although not used in the publication. Hawes was associate director of the Museum of Fine Arts, Boston, and later taught at Dartmouth College. In this pair of images the same two subjects are posed in front and side views before a plain drop cloth, which was used to create a neutral background.

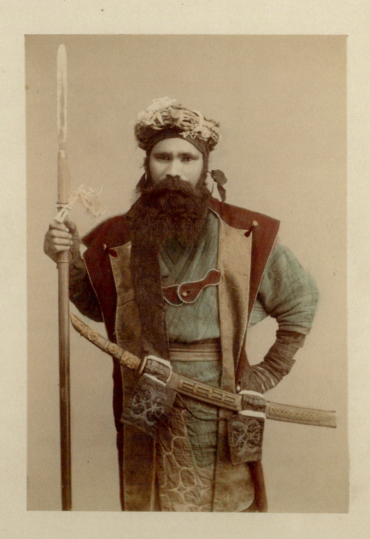

Scenes in Japan.

hair, among other attributes. Occasionally, however, physical type images were used to challenge prevailing theories, such as in an image from the Peabody collection of an Ainu man (see p. 73, left) whose relatively hairless body was posited as a visual challenge to the prevailing theory that Ainu people had "excessive" amounts of body hair. Like their commercial counterparts (souvenir images of Ainu and Japanese subjects), such photographs had a global circulation; photographs of Ainu subjects produced by Japanese and Western photographers and scientists for specifically scientific use continued into the twentieth century. They accumulated in individual and institutional collections along with other kinds of images, including postcards, stereographs, and cartes-de-visite. A massive body of such images was created during the early years of modern Japanese control of formerly Ainu lands, and many can still be found in the world's major ethnographic museum collections.[46]

Scientific images of Ainu subjects must be understood as part of the larger visual economy of images of Japan, in which photographs were produced, marketed, sold, purchased, and circulated globally, even if the people depicted were not considered fully "Japanese." Commercial versions of Ainu subjects were frequently collected together with Japanese images, whether in prepackaged souvenir albums or as loose photographs. These were versions of type images, sold on the commercial market, that typically included more cultural context (such as clothing and objects of material culture) than their starker, more body-focused scientific counterparts. Such images played a crucial role in the effort to "salvage" the remnants of vanishing peoples and cultures, an endeavor that provided both scientific and popular rationale for most of the collection of early Japanese photographs in the Peabody Museum.

Ainu Man (Scenes in Japan), 1880s. Photographer unknown. Albumen print on paperboard mount. Print: 13.1 × 8.9 cm (5¹⁄₈ × 3¹⁄₂ in.); mount: 21.6 × 16.5 cm (8¹⁄₂ × 6¹⁄₂ in.). Collected by James S. Paine, c. 1886–1906. Gift of James L. Paine, 1936. PM 36-26-60/15986.27 (101420010).

A handwritten caption on the verso of this image of an Ainu man presented in a standard "type" photograph identifies him as an "actor." It is likely (although not certain) that the caption was written by the collector, but the terminology unintentionally highlights the staged nature of this image in particular, and of the photography produced more generally for tourists and anthropologists alike.

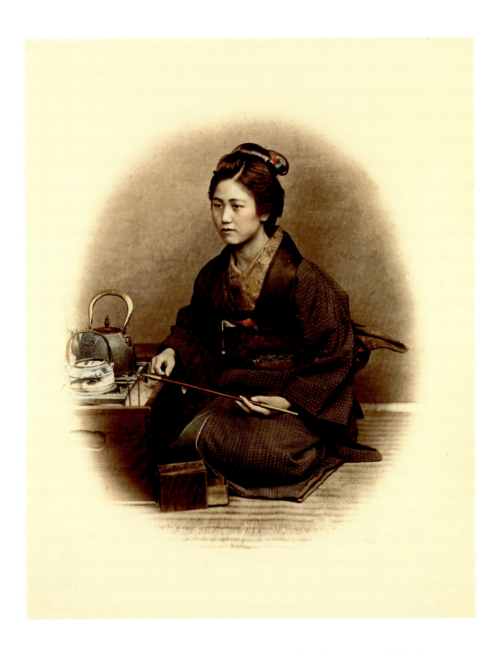

Woman with pipe, 1870s. Studio of Stillfried & Andersen Co., Raimund von Stillfried, photographer. Hand-tinted albumen print, 23.5 × 19.2 cm (9¼ × 7½ in.). Collected by William S. Bigelow, 1880s. Gift of Mary Lothrop, 1927. PM 2003.1.2223.308 (96850003).

Foreign observers in the Meiji period often noted that it was common for both men and women to smoke in Japan, and many commercial photographs of the era document the practice, especially in images that feature women smoking pipes (*kiseru*). The small bowl of the kiseru held a pinch of tobacco, enough for a very few puffs. Smokers typically emptied the smoked tobacco into a brazier, as this image shows, before refilling. Some observers noted that women kept pipes in kimono sleeves or sometimes in their hair.

CHAPTER 4

Visual Salvage

∞

*[N]othing can be of greater importance than the study of those
nations and peoples who are passing through profound
changes and readjustments as a result of their compulsory
contact with the vigorous, selfish, and mercantile nations of
the West, accompanied on their part by a propagandism in
some respects equally mercenary and selfish. Thanks to the
activity of a number of students of various nationalities in the
employ of the Japanese government, and more especially to the
scholarly attachés of the English legation in Japan, much
information has been obtained concerning this interesting
people which might otherwise have been lost.*

—Edward S. Morse[47]

With the 1917 publication of *Japan Day by Day*, his two-volume cultural
memoir of life in Japan, Edward Sylvester Morse finally heeded his friend
William Sturgis Bigelow's admonition to "drop your damn brachiopods" and
document the "vanishing types," the "Japanese organisms which you and I
knew familiarly forty years ago." But many years earlier, in 1885, Morse had
already praised foreign consultants for, in effect, salvaging information about
aspects of Japanese cultural life that he saw as endangered, and had called on
young Japanese people to follow suit.[48]

Like many other foreign observers, Bigelow and Morse were concerned
with what they perceived as the impending demise of traditional culture in
Japan, brought about by the nation's race to modernize. The government's
intense focus on modernization was central to foreign and domestic thinking

about Japanese culture, history, and the future of the nation. Observers such as Bigelow and Morse typically used the dichotomy of modernity and tradition as a way to alternately criticize and praise Japanese culture and society. Japanese government planners and other powerful leaders saw the infrastructural and social transformation into a modern nation in line with Western models as absolutely critical to Japan's survival as an independent country. Bigelow's and Morse's concern was thus indicative of a much wider cultural moment in Western attitudes about Japan.

The story of how this moment played out visually is embedded in the Peabody Museum's collections of Japanese images. We have already seen how the scientific concept of the "type" informed the development of nineteenth-century anthropological photography, and how the structures of colonialism were an essential component in photographic production. In the independent nation of Japan, however, very little such photography was produced; instead, commercially made images of Japanese subjects filled the void. The Peabody's Japanese collections consist of photographs almost exclusively acquired from commercial stocks, which were otherwise primarily sold as souvenirs to foreign tourists. Surfacing the relationship between souvenir photography and early anthropology's interest in Japan demonstrates that no matter how tempting it may be to claim rigid parameters for photographic categories based on image content, the porous boundaries between science and tourism in the late nineteenth and early twentieth centuries allowed for multiple meanings to be derived from images. Furthermore, understanding the dynamic nature of photographic meaning in this context exposes the larger issue of the salvage mentality that framed outside views of Japan, which in turn fostered even greater cross-pollination between scientific and touristic photography, and also influenced the collecting practices that resulted in the particular holdings owned by institutions such as the Peabody Museum.

Salvaging Japan

The idea of salvaging non-Western cultures gained currency in the second half of the nineteenth century. The devastating and often genocidal effect of colonial encounters on native peoples was recognized and even lamented by some colonial administrators, missionaries, and others in both the colonies and the colonizing nations. The salvage mentality emerged out of this realization in conjunction with ethnological thinking, as science turned its attention to count-

ing, classifying, and recording human "races." A sense of anxiety developed around the need to document and quantify these races before they vanished. As James Clifford put it, the salvage paradigm held that "the other is lost, in disintegrating time and space, but saved in the text."[49] The non-European "other" could be saved in the written ethnographic text and also in visual "texts," scientific or otherwise.

Although Japan was one of only a relatively few non-Western nations to have evaded colonization, it did not escape multifaceted attempts to salvage what many foreigners and some Japanese mourned as its dying traditions in the face of increasing contact with Western cultures and technologies. In colonial societies it was virtually unquestioned that native peoples were doomed to extinction, both culturally and physically. In Japan, however, the unstoppable agent of change was modernization. Here native extinction was seen as a loss of "traditions" rather than the death of a species. Thus when Bigelow calls the Japanese a "vanishing type," he is referring to cultural rather than physical losses.

Japan's situation, then, cannot be uncritically equated with that of the colonies; instead, to borrow Michael Herzfeld's formulation, it is useful to think about Japan in the second half of the nineteenth century as crypto-colonial. Crypto-colonialism describes a variant of colonialism wherein a state is politically independent but simultaneously heavily dependent economically on what would otherwise be considered the colonizing power. This nominal independence, Herzfeld posits, "comes at the price of a sometimes humiliating form of effective dependence."[50] Japanese political leaders calculated that the price for preventing the kind of colonial and semicolonial domination experienced by their neighbors in Asia was the crypto-colonial accommodation of Western demands for trade, for example, as well as self-styled "modernization," imported via foreign consultants working in Japan and Japanese study missions abroad. Although Japan's external economic and political relations were highly regulated, they were not entirely controlled by a foreign government.

The Japanese situation was closer to that of Siam (now Thailand) and the late Ottoman Empire than to regions that experienced direct colonial rule on the African continent or in South Asia. Japan was under severe political pressure from several Western countries to allow increased international economic activity and admit greater numbers of foreigners to its shores during this period. This followed over two hundred years of Japanese seclusion policies, first enacted by the Tokugawa shogunate in the 1630s when it began to fear possible colonial aggression on the part of Spain and Portugal. The shogunate also fretted over

the growing influence of Christian converts in Japan, and wanted to consolidate central government control over international trade. It restricted foreigners from direct access to Japan, and Japanese from traveling abroad. These policies were lifted under pressure from the United States and other Western countries in a series of treaties in the late 1850s. Although Japan was not forced to cede any territory to foreign control, these treaties severely restricted Japanese sovereignty by granting extraterritoriality to Westerners, essentially exempting them from Japanese law, and gave Western countries the right to regulate tariffs.[51]

In the absence of a colonial regime, the work of salvaging Japanese culture within this crypto-colonial context fell to diverse groups of people: foreign residents in Japan, scholars, popular writers, tourists, and others with a serious interest in the country. This situation resulted in a dearth of scientific research on Japanese physical types and their supposed endangerment. Instead, many popular texts about Japan incorporated scientized ideas about the Japanese "race," which inevitably noted the imminent demise of ancient traditions in the face of unstoppable modernization. The modern in Japan was routinely dismissed as tacky, coarse, imitative, and ugly. Travel writers, including scholars of Japan such as Basil Hall Chamberlain and W. B. Mason, who contributed to the popular guidebook *Murray's Handbook* and whose academic standing lent credibility to their writings, implored readers to visit the country before it was "too late," poised as it was on the verge of inevitable change. Few people seemed to question whether or not this change could be stopped, even if to some that would have been desirable. Diplomats, businessmen, government consultants, and other observers trumpeted the fading "samurai spirit" and lamented Japan's cultural losses, expressing disgust at what they viewed as the mindless aping of Western culture. At the same time, they praised the country's rapid industrialization and emergence from feudalism, especially when compared with other non-Western (colonized) societies.[52]

One arena in which cultural salvage occurred was in the purchasing of artifacts of Japanese material and visual culture. Objects such as kimono, pottery, lacquerware, and bronzeware were highly coveted by scientists, art collectors, and tourists alike. For most foreigners, purchases in Japan would have amounted to nothing more than touristic consumption of exotica, although this kind of consumerism may have been influenced by the notion of cultural salvage.

Other collectors, such as Bigelow and Morse, had both big budgets and a scholarly understanding of Japan, and for them collecting was consciously associated with salvaging Japanese culture for art historical or scientific purposes.

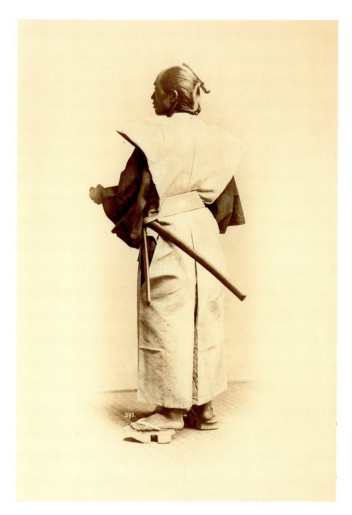

"Before" image in Japanese dress and "after" image in Western formal dress, 1870s. Studio of Stillfried & Andersen Co., Raimund von Stillfried, photographer. Albumen prints, *left:* 22.9 × 15.3 cm (9 × 6 in.), *right:* 21.6 × 13.8 cm (8½ × 5⅜ in.). Collected by William S. Bigelow, 1880s. Gift of Mary Lothrop, 1927. PM 2003.1.2223.407 and .408 (96900003, 96900004).

This set of photographs shows a man, ostensibly a samurai, who has been transformed into a gentleman wearing top hat and tails. The tuxedoed figure in the "after" image embodies the aspirations of achieving westernization and modernization. The bad fit of the costume, however, can also be read as a comment on the impossibility of these goals. The failure of "fit" subverts the idea that a Japanese could truly become "Western" or "modern," and relegates him instead to a poor imitation of the original.

Japonisme, too, helped shape the desires of tourists and serious art collectors alike, who returned home with examples of visual art forms such as ukiyo-e, painted screens, and ceramics. Many observers felt that collecting in Japan had reached such a level of intensity by the late nineteenth century that Chamberlain, for one, complained, "Japan is now almost denuded of old curios. Some have found their way into the museums of the country while priceless collections have crossed the sea to Europe and America."[53] In what might be called "self-salvage," the export of Japanese art came to be seen as a loss of national patrimony by influential Japanese, including nationalist art historian Kakuzo (also known as Tenshin) Okakura, who successfully advocated for the enactment of laws controlling cultural properties, including the right for the emerging national museum to collect antiquities whose ownership could not be established.[54]

Incense burner in the form of a cat, n.d. Japanese. Brass and enamel with gold plating, 7.3 × 12 × 9.1 cm (2⁷/₈ × 4³/₄ × 3¹/₂ in.). Collected and donated by Henrietta Page, 1927. PM 27-22-60/E3286 (99080004). Mark Craig, photographer.

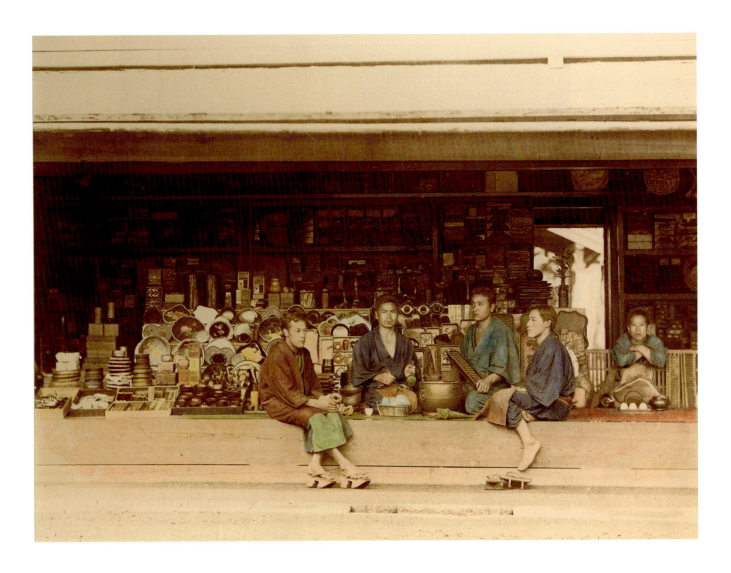

Curio shop, 1870s–80s. Photographer unknown. Hand-tinted albumen print, 17 × 22 cm (6 ¾ × 8 ¾ in.). Collected by William S. Bigelow, 1880s. Gift of Mary Lothrop, 1927. PM 2003.1.2223.403 (96890005).

Curio shops proliferated in the Meiji period as foreign tourists came to Japan in increasing numbers. These shops stocked a range of souvenirs, including ceramics, lacquerware, swords, textiles, and other Japanese objects of interest to Westerners.

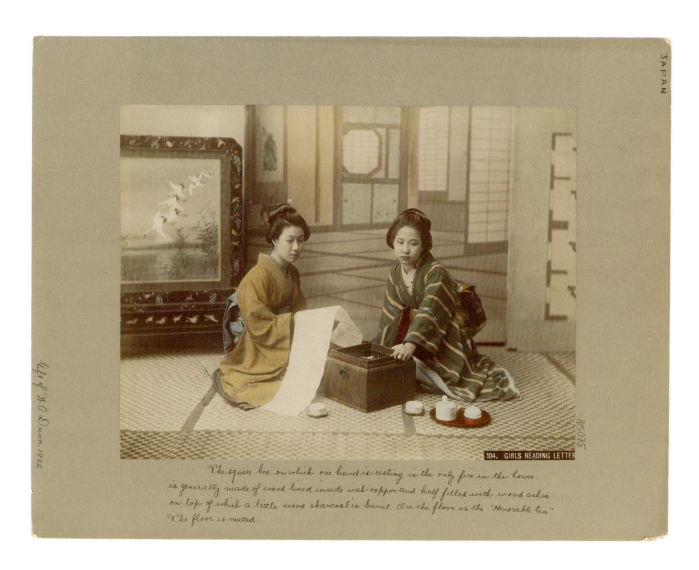

Girls Reading Letter, 1880s–90s. Studio of Kimbei Kusakabe. Hand-tinted albumen print on paperboard mount. Print: 19.2 × 25.3 cm (7 ¾ × 10 in.); mount: 27.9 × 35.5 cm (11 × 14 in.). Collected by William A. Dunn. Gift of William A. Dunn, 1922. PM 2003.1.2223.373 (101160016).

The handwritten (perhaps by the donor) caption reads: "The square box on which one hand is resting is the only fire in the house—is generally made of wood lined inside with copper and half filled with wood ashes on top of which a little wood charcoal is burnt. On the floor is the 'honorable tea.' The floor is matted."

for sale overseas. In keeping with the salvage mentality and interest in an exotic other, souvenir photographs rarely included images of the cars, trains, electric wires, or Western-inspired architecture that would have been an inescapable part of the visual landscape of a rapidly modernizing Japan.[55]

Not all acquisitions of tourist photographs can be considered acts of cultural salvage, of course. As with curios, many travelers must have purchased photographs simply as mementos of their visit. But considering the rhetoric of tourism, which repeatedly emphasized that "much which is now quaint and curious will soon disappear,"[56] it is fair to speculate that many tourists also collected photographs as documents of a vanishing way of life.

What is more relevant to our discussion here, however, is how photographs intended for the tourist market were eventually deposited in the Peabody and other museums of anthropology, where the idea of salvage was unambiguously a core mission. In the nineteenth century, early souvenir photographs of Japan were accessioned throughout North America and Europe by such notable institutions as the Pitt Rivers Museum (University of Oxford), the Museum Volkenkunde (National Museum of Ethnology, Leiden, the Netherlands), and the National Museum of Natural History (Smithsonian Institution), to name but a few. In the absence of Japanese images produced specifically for scientific purposes, commercially produced portraits served as the principal bridge between the scientific desire to obtain data about Japanese physical types and culture, and touristic curiosity about an exotic people and place. As I have argued elsewhere, the production and circulation (including museum collecting) of such photographs can be characterized as "visual salvage."[57] Just as ethnographies and other texts attempted to preserve the world's vanishing types through written description, photographs could preserve them in visual form. Photographs both sustained and were sustained by salvage thinking in ways that allowed them to move seamlessly between the environment of souvenir photography studios and museums of anthropology.

Native Types

As Luke Gartlan has observed, scholars and collectors alike have typically referred to nineteenth-century commercial photographs of Japanese individuals as "native types" (sometimes called "portrait types").[58] This genre of photography, which encompassed colonial subjects throughout the world (including Native Americans), extended the appeal of the human subjects of type photographs

beyond their original, scientific purposes by aestheticizing the human subjects.[59] Scholars have always cited the title of Beato's most important work, a two-volume souvenir album, as "Views of Japan" and "Native Types."[60] Gartlan's research on an 1868 edition of this album has established that neither volume was originally titled "Native Types." Nevertheless, the Victoria and Albert Museum in 1918 indexed the accession under that new title.[61]

Early photography studios in Japan used the word "costume" rather than "native type" to market their products. "Costume" originally referred to an illustration, usually a watercolor on paper, that depicted foreign (to Europeans) people dressed in native style, engaged in various occupations or activities. This genre was a major source of information about Asian cultures in the pre-photography colonial era, and Beato established the "costume" as the standard genre in the early Japanese souvenir photography industry.[62] This is an important corrective because it grounds Japanese souvenir photography in an older, prephotographic tradition of Western representations of Asia, and shows that Beato and others chose to market their work with this name rather than with native types or other categories of images. It has long been recognized that themes and techniques from ukiyo-e provided models of content and aesthetic inspiration to photography, but more research on the costume genre's impact on Japanese photography remains to be done.

Despite the difference between studio and museum nomenclature, however, early Japanese "costume" souvenir photographs were indeed equivalent to native types in meaning, use, subject matter, and conception, especially in the 1870s and later, as anthropology matured as a discipline and its interest in studying the cultures of colonial subjects was echoed in wider society. The pre-photography costume genre satisfied a demand—overlapping, but more commercial than scientific—for pictures of exotic people and places. Like costume and native type photographs, costume illustrations were later archived as anthropological material, which clearly indicates the scientific interest in the subject matter, regardless of its highly aestheticized presentation.[63]

Native types gained global distribution with the advent of the carte-de-visite, a format patented in 1854 that became widespread in the 1860s. These compact photographs were generally albumen prints measuring $2\frac{1}{2} \times 4$ inches, pasted on paperboard backings and sold at inexpensive prices. A specialized camera capable of taking multiple exposures on a single negative plate made the process efficient and cost-effective. These qualities made mass production (and big profits) possible. In addition to cartes-de-visite and cabinet prints (essentially larger versions of cartes-de-visite, measuring $4\frac{1}{2} \times 6\frac{1}{2}$ inches),

native types were also printed in more expensive large-format sizes (8 × 10 inches). Native type cartes-de-visite (and carte-de-visite-sized prints) are found in great numbers in anthropological museum and archival collections in Europe and North America. In the Peabody Museum, cartes-de-visite of native types have been archived together with human curiosities, underscoring the anthropological interest in bodies that differed from the "norm."

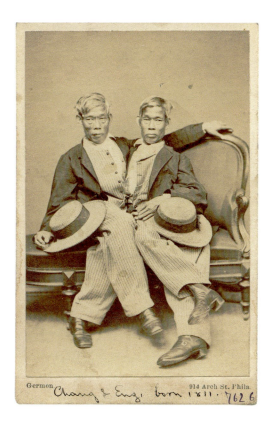

Chang and Eng, c. 1866. Studio of W. L. Germon's Temple of Art. Carte-de-visite. Print: 10.2 × 6.4 cm (4 × 2¹/₂ in.). PM 2004.1.287.1 (99040077).

Like other museums with anthropological collections, the Peabody Museum holds numerous images of what were considered nonstandard bodies. One example is this carte-de-visite portrait of Chang and Eng, who were known as the "Siamese Twins," which became the generally used term for conjoined twins. Born in Thailand (then Siam) in 1811, they began touring the United States and other countries in 1829 and became one of P. T. Barnum's most popular attractions. A handwritten note on the back of the card lists a date of January 22, 1866.

Predictably, the Peabody Museum collection includes cartes-de-visite of Ainu subjects, Japan's "internal others," who were frequently the target of the anthropologist's and tourist's cameras alike. It also includes carte-de-visite-sized prints of (non-Ainu) Japanese subjects, although there are far fewer of these than of larger prints. The fact that Western museums have substantial collections of Japanese native types further attests to their global circulation. Whatever label the studios originally used for their products, they would have been keen to tap into the global market for ethnographic images of non-Western peoples. Being non-Western qualified Japanese subjects as native types for tourists and other collectors, and as data for inclusion in museum visual archives.[64]

Native types pictured subjects as representatives of a specific "type" of human being, such as "Village Maiden," "Native Warrior," or "Aboriginal" (see p. 93, left). In that way, they did not differ significantly from anthropometric and other physical type photographs made specifically for scientific consumption: both were interested in distilling racial and cultural essence into a photographic print, making the specific stand for a generality.

But native types differed from anthropological photographs in their production because they did not use a methodology drawn directly from emerging scientific practice to gather data for research on human racial difference, nor were they primarily intended for the scientific market. In targeting the commercial market, industry practitioners instead took their cues on how to present, compose, and caption images of non-Western people from the subject matter of anthropological photography and the aesthetics of bourgeois portraiture, blending the two (see p. 93, right).

The resulting highly aestheticized genre proved to be well suited to the Japanese case. Japan provided the exotic subject matter desired by many Western consumers, but not the colonial conditions necessary for the more repressive forms of scientific photography, leaving Japanese subjects perfectly situated for

"Historic Board" with twelve cartes-de-visite of Ainu subjects, 1880s. Unknown photographer(s). Albumen prints on paperboard mount. Prints: approx. 10 × 6 cm (3⅞ × 2⅜ in.) each; mount: 35.4 × 28 cm (14 × 11 in.). Gift of K. Miyabi. Transfer from the Museum of Comparative Zoology, Harvard University. PM 2003.1.2223.241–.252 (101160011).

This H-Board was catalogued by early twentieth-century museum staff as "Aino" (a mistransliteration of "Ainu") rather than "Japan."

AINO

2003.1.2223.241 H15424
2003.1.2223.242 H15425 (Japan)
2003.1.2223.243 H15426
Box III
2003.1.2223.244 H15427

2003.1.2223.245 H15428
2003.1.2223.246 H15429
2003.1.2223.247 H15430
2003.1.2223.248 H15431

2003.1.2223.249 H15432
2003.1.2223.250 H15433
2003.1.2223.251 H15434
2003.1.2223.252 H15435

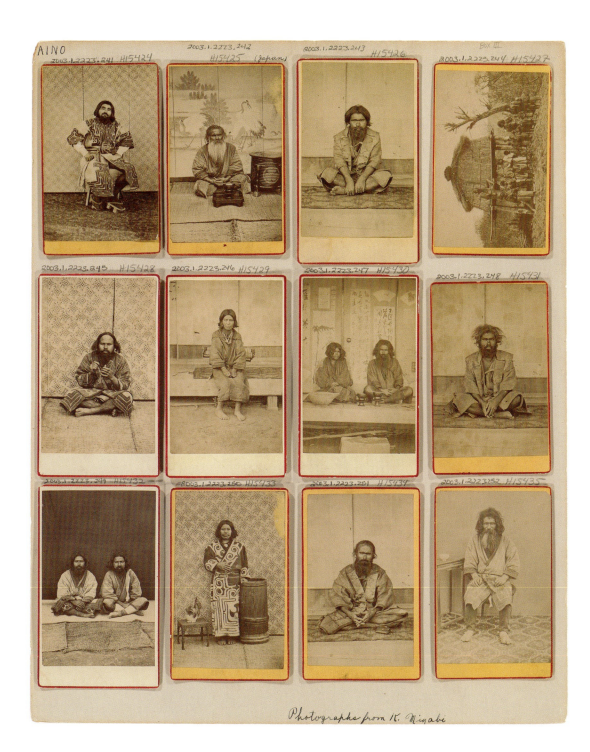

Photographs from K. Niyabe

Japan

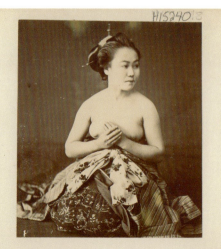

H15240

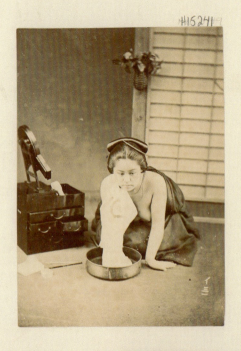

H15241

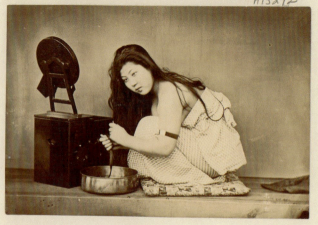

H15242

H15243

Gift of Miss Mary Lothrop. 1927.

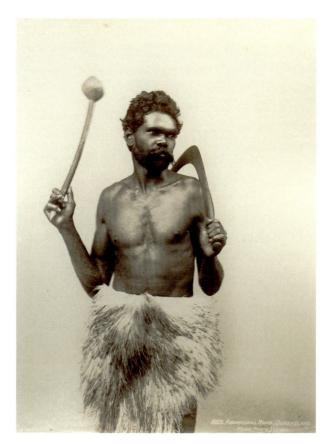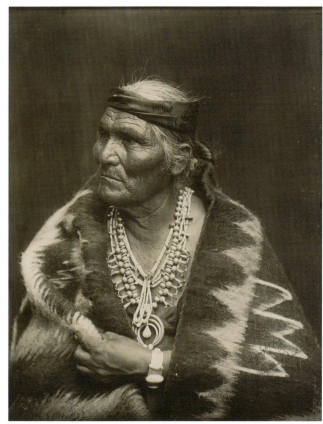

Aboriginal. Roma, Queensland, c. 1890s. Studio of Kerry and Co. Albumen print, 20.3 × 15 cm (8 × 5 ⁷⁄₈ in.). PM 2004.29.21769 (99040080).

An Indian Judge (Navajo), c. 1914. William M. Pennington and Wesley R. Rowland, Durango, Colorado. Albumen print on paperboard mount. Print: 25.1 × 20 cm (10 × 7 ⁷⁄₈ in.); mount: 35.3 × 27.9 cm (13 ⁷⁄₈ × 11 in.). Gift of Alfred V. Kidder, 1914. PM 2004.29.4208 (101160022).

OPPOSITE

Four images of partially dressed women grooming, 1870s–80s. Photographers unknown. Hand-tinted albumen prints on paperboard mount. Prints: *top:* 8.2 × 9.6 cm (3¹⁄₂ × 3 ⁷⁄₈ in.), PM 2003.1.2223.137; *middle left:* 9.3 × 13.3 cm (3 ⁵⁄₈ × 5¹⁄₄ in.), PM 2003.1.2223.138; *middle right:* 13.6 × 9.4 cm (5 ³⁄₈ × 3 ³⁄₄ in.), PM 2003.1.2223.139; *bottom:* 13.6 × 9.4 cm (5 ³⁄₈ × 3 ³⁄₄ in.), PM 2003.1.2223.140. Mount: 35.3 × 27.9 cm (13 ⁷⁄₈ × 11 in.), PM 2003.1.2223.137–.140 (101160005). Collected by William S. Bigelow, 1880s. Gift of Mary Lothrop, 1927.

what could be considered a middle-ground visual representation. This middle ground, with its massive and varied audience, encompassed a wide swath of Japanese photography. Rather than existing as fixed, discrete categories of images, then, early Japanese photographs traveled on a continuum that allowed different viewers and users to satisfy different desires.

Creating successful native types required the production of an aesthetically pleasing presentation replete with cultural markers of difference. Whereas physical type photography tended to strip away cultural context, arranging subjects (often without much or any clothing) in front of neutral backdrops in order to emphasize the (apparently) unmediated body, native types often featured elaborately costumed subjects, painted backdrops or other scenery, props, and often—especially in the case of Japanese photographs—exquisitely hand-tinted surfaces. Scenes that conformed to Western consumers' cultural and aesthetic expectations provided guidance for creating compositions for some Japanese native types.

Even without the added "authenticity" of a scenic Japanese backdrop, a non-Western, exotic subject was enough to qualify a native type as a tourist souvenir in the eyes of travelers and as an ethnographic object in the eyes of anthropologists. It must have appeared very novel indeed to viewers at the time to see a samurai-diplomat posed in a fashionable mid-nineteenth-century Paris or New York studio setting rather than a feudal castle interior. Similar images of elegantly attired and distinguished-looking gentlemen were made into stereographs for popular consumption. At the same time, the Japanese diplomatic mission presented the same photographs to heads of state, European royalty, and government officials as cabinet prints and other formats suitable for formal portraits, rather than as curiosities.[65] Despite the exalted social status of the subjects within their own cultural context, it was nevertheless possible for curators and archivists to consider photographs of these dignitaries to be appropriate anthropological museum objects. In a similar vein, portraits of the Meiji emperor and empress were popular souvenir photographs, but also functioned as type images that comprised anthropological data for the museum.

Girl in Winter Evening, 1880s. Photographer unknown. Hand-tinted albumen print. 26.4 × 19.7 cm (10 ³⁄₈ × 7 ³⁄₄ in.). Collected by George B. Gordon, 1898. Gift of George B. Gordon, 1898. PM 2003.1.2223.378 (101410019).

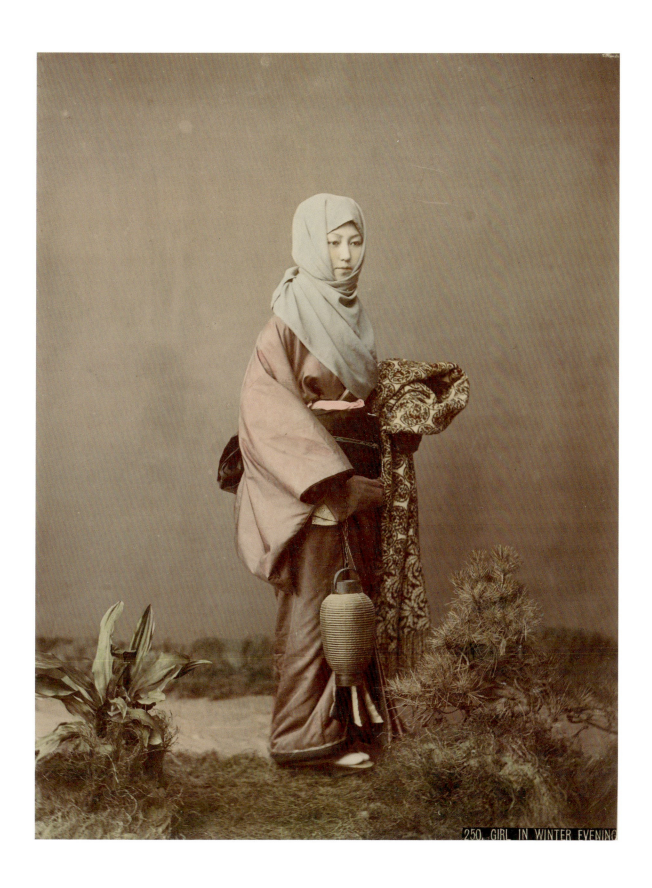

250. GIRL IN WINTER EVENING

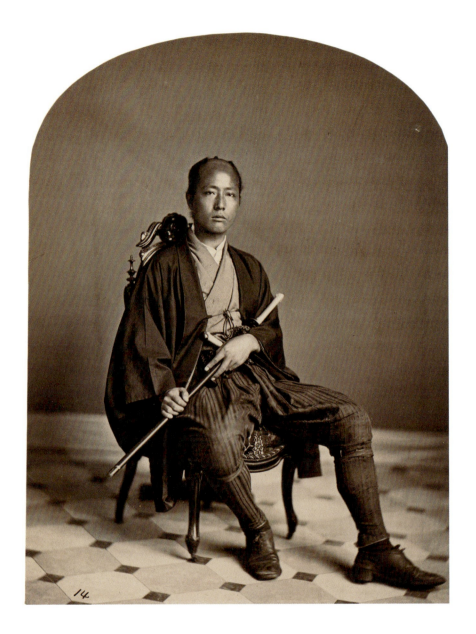

Japanese diplomat in New York, 1860. Charles D. Fredericks. Salt print. Print: 20.2 × 15 cm
(8 × 6 in.). Transfer from the Museum of Comparative Zoology, Harvard University.
PM 2003.1.2223.416 (101420017).

This portrait and the stereoviews (opposite) were taken in New York City during an 1860
Japanese diplomatic mission to the United States. It was Japan's first trans-Pacific mission,
and it created a huge public sensation, with parades, balls, and extensive newspaper cover-
age. For scientists, commercial images produced for general public consumption were equally
valuable as visual data for anthropological research, and this photograph (along with others
from the 1860 mission) was accessioned by the Museum of Comparative Zoology before
being transferred to the Peabody Museum.

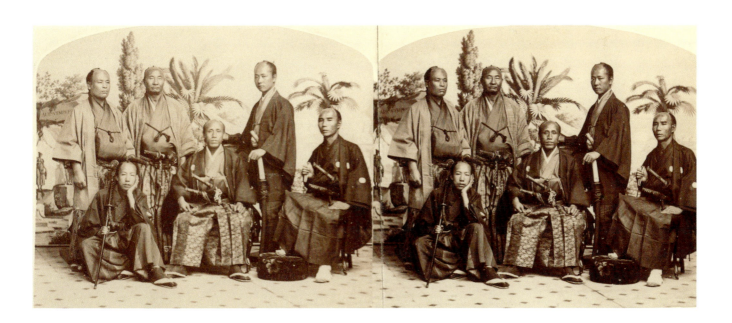

Japanese diplomats in New York, 1860. Charles D. Fredericks. Albumen prints on stereograph card. Prints: approx. 6.8 × 15.5 cm (2 ⅝ × 6 ⅛ in.); stereocard: 8.5 × 17.9 cm (3 ⅜ × 7 in.). Transfer from the Museum of Comparative Zoology, Harvard University. PM 2003.1.2223.426 (101420027).

The overwhelming majority of models used in native types, however, were not elite, paying clientele but, rather, members of Japan's underclass—including, as we have seen, sex workers—who were unlikely to have had much agency in controlling their image. In this regard, the crypto-colonial economic and political conditions in Japan were similar to those of colonial societies, which were conducive to native types being produced partly as a commercial form of salvage. If traditional Japanese culture was believed to be in danger of vanishing, then photographs could at least document remaining customs and material culture, and photography could supply an endlessly reproducible image that operated perfectly within the salvage paradigm. Toward this end, models portrayed a wide variety of characters performing in various situations that were intended to illustrate social and cultural practices and examples of Japanese material culture for the tourist market. From a contemporary standpoint, it might seem that this artificial commercial approach would invalidate any documentary or scientific value of the photographs, but the large numbers of native types in the

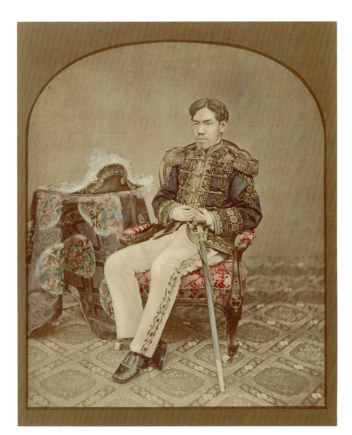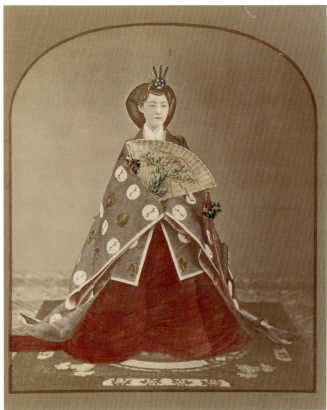

Emperor Meiji, 1872. Studio of Stillfried & Andersen Co., Kuichi Uchida, photographer. Hand-tinted albumen print, 23.6 × 18.9 cm (9¼ × 7½ in.). Collected by William S. Bigelow, 1880s. Gift of Mary Lothrop, 1927. PM 2003.1.2223.347 (101150023).

Empress Haruko, 1872. Studio of Stillfried & Andersen Co. studio imprint, Kuichi Uchida, photographer. Hand-tinted albumen print, 23.5 × 18.9 cm (9¼ × 7½ in.). Collected by William S. Bigelow, 1880s. Gift of Mary Lothrop, 1927. PM 2003.1.2223.348 (101150025).

world's anthropology museums indicate that this was not the case for anthropologists of the time.

Many native types reflected a popular interest in "race" generated by new ideas in anthropology and other sciences linking the body to culture and non-physical qualities such as intelligence and criminality. An emphasis on physiognomy is obvious in many images that display a concern with such issues as body modification, and that show the subject in the frontal and profile views typical of anthropological imagery. Images of horse grooms were especially popular, for

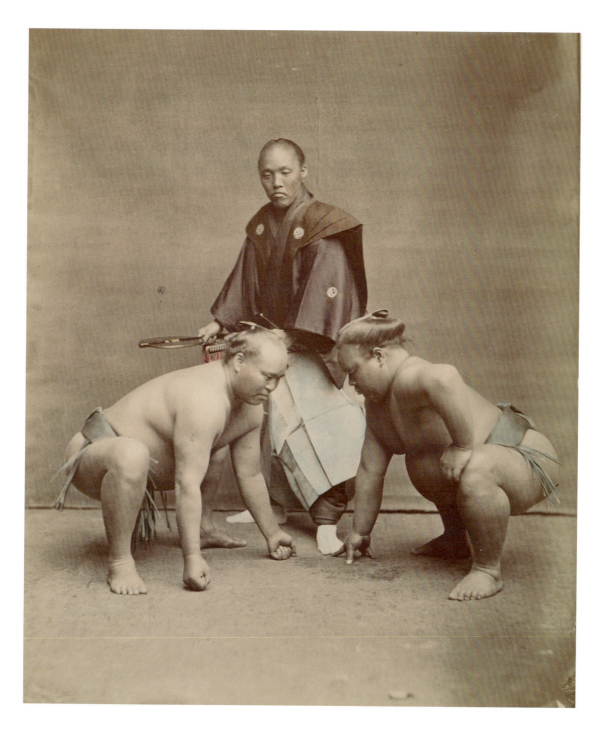

Sumo players and referee, 1880s. Unknown photographer. Hand-tinted albumen print,
23.4 × 19.1 cm (9¼ × 7½ in.). Collected by William S. Bigelow, 1880s. Gift of Mary Lothrop,
1927. PM 2003.1.2223.354 (101150027).

H15049

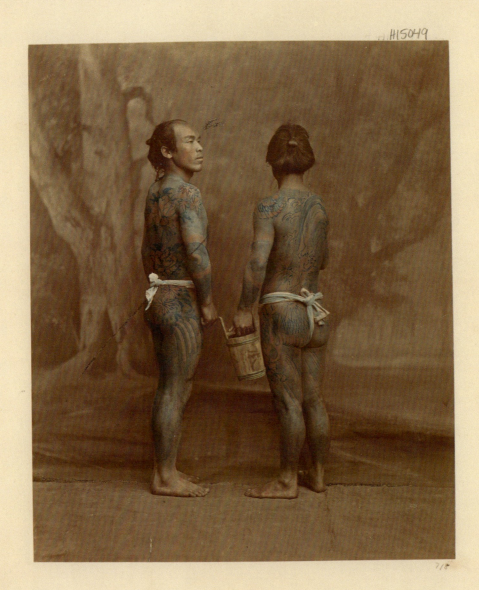

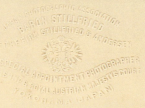

Scenes in Japan.

Women Displaying Hair (Scenes in Japan), 1880s. Photographer unknown. Hand-tinted albumen print on paperboard mount. Print: 8.6 × 13.1 cm (3³⁄₈ × 5¹⁄₈ in.); mount: 16.5 × 21.6 cm (6¹⁄₂ × 8¹⁄₂ in.). Collected by James S. Paine, c. 1886–1906. Gift of James L. Paine, 1936. PM 36-26-60/15986.111 (101160001).

OPPOSITE

Tattooed men, 1870s. Studio of Stillfried & Andersen Co., Raimund von Stillfried, photographer. Hand-tinted albumen print on paperboard mount. Print: 23.5 × 19.2 cm (9¹⁄₄ × 7 ¹⁄₂ in.); mount: 35.4 × 27.9 cm (14 × 11 in.). Collected by William S. Bigelow, 1880s. Gift of Mary Lothrop, 1927. PM 2003.1.2223.355 (101160015).

This pairing of two men with full body tattoos can be firmly located in the native type genre. Although the artfully painted backdrop (probably painted by Stillfried himself) and beautifully hand-tinted surface of the photograph suggest luxury, the seminaked state and poses of the two subjects have more in common with scientific physical type photography than with bourgeois portraiture.

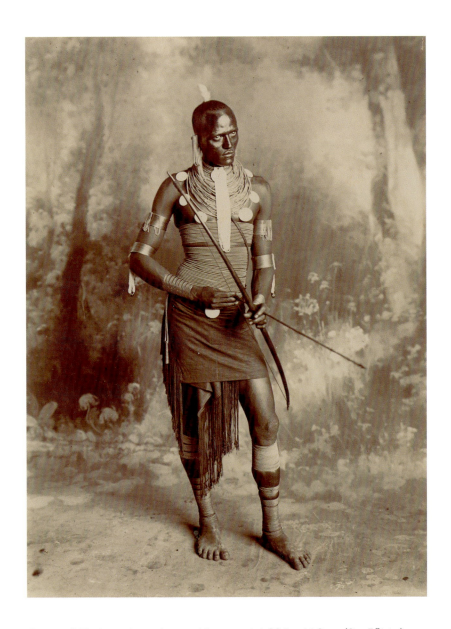

Bantu, n.d. Photographer unknown. Albumen print, 20.5 × 14.8 cm (8 × 5 ⅞ in.).
Collected by Alexander Agassiz. Transfer from the Museum of Comparative Zoology,
Harvard University, 1914. PM 2004.29.12105 (detail of 101160025).

The juxtaposition of these two images demonstrates the striking similarity in composition
of native types representing cultures from around the world, including Japan. The two
subjects here, both ostensibly warriors, are posed in front of painted studio backdrops.
Their costumes and weapons—as much as their phenotypes—mark them as distinct from
the modern militaries of the implied Western viewers.

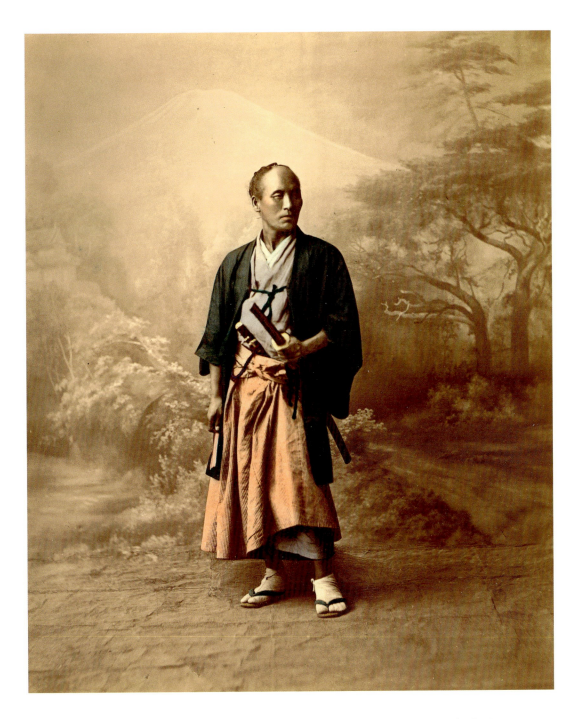

Man in samurai regalia, 1870s. Studio of Stillfried & Andersen Co., Raimund von Stillfried, photographer. Hand-tinted albumen print, 23.6 × 19.1 cm (9¼ × 7½ in.). Collected by William S. Bigelow, 1880s. Gift of Mary Lothrop, 1927. PM 2003.1.2223.341 (96930002).

H14999

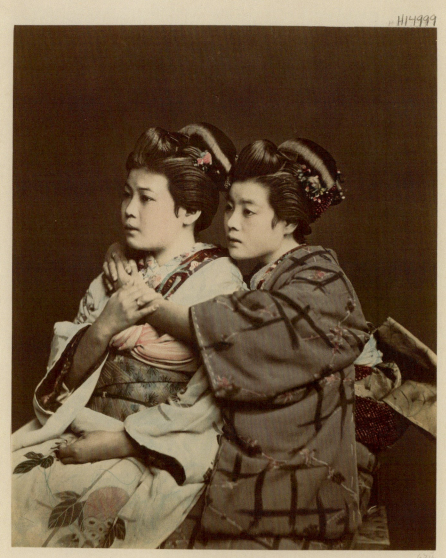

674

Good hair —
Details of sash & knot.

example, as they allowed for the display of near-naked tattooed subjects (see p. 100). Along with tattooed male bodies, women's hair was a particularly well-represented subject. Countless images show women having their hair styled, sleeping on wooden pillows in order to preserve the resulting elaborate hairstyles, or simply displaying their hair (see pp. 101, 104).

Photographers themselves were also well aware of the anthropological market for their photographs of Japan. The striking consistency in format, composition, and theme between Japanese and other native types from the colonized world points to a conscious referencing of this global style (see pp. 102, 103). Stillfried, for example, received critical praise for his studies of Japanese physiognomy and even lectured to the Anthropological Society of Vienna, using his own photographs as illustrations. Several of Stillfried's and Beato's photographs of Japanese subjects were repurposed as etchings in type studies in the 1880s, including one commissioned by the German government.[66]

Ultimately, the meanings of commercial photographs of Japanese subjects were not defined by the tourist market, but were instead malleable enough that such photographs could be equally suitable on the shelf of a Yokohama commercial photographer's studio and in the photographic archives of a museum of anthropology in Cambridge, Massachusetts. The photographs that have made the journey from Japan to the Peabody Museum continue to be transformed, as we reframe them in our own time.

Two women ("Good hair"), 1870s. Studio of Stillfried & Andersen Co., Raimund von Stillfried, photographer. Hand-tinted albumen print on paperboard mount. Print: 23.5 × 19.2 cm (9¼ × 7¾ in.); mount: 35.6 × 28 cm (13⅞ × 11 in.). Collected by William S. Bigelow, 1880s. Gift of Mary Lothrop, 1927. PM 2003.1.2223.305 (101160012).

The two models in this photograph have been carefully posed and the surface has been painstakingly colored, highlighting various elements of bodily adornment. Bigelow's handwritten caption calls attention to the models' "Good hair," presumably because the hair demonstrates an ideal or typical hairstyle, in much the same way that he dubbed the first image in this volume "A good type" (see frontispiece).

CHAPTER 5

Visualizing the Future

∞

There is a great sense of anticipation, of imminent discovery, when exploring photographic archives. The long-forgotten images housed in storage boxes, sometimes bearing the musty scent of old paper, signal the passage of time. A photograph's physical size always seems to be larger or smaller than one expected, even if one has read the dimensions beforehand, in preparation for the visit. Photographs that appeared as digital images on a computer screen during online research sessions, no matter how vivid and accurate their visual representation, insist on making their material presence known when handled in person.

The smell, heft, size, and other sensory aspects of the photographs discussed in this book continue to surprise and intrigue me, many years after my first encounter with them. The sumptuous surfaces of the hand-tinted photographs demand close observation not only of the image and its content but also of the object, the print itself—perhaps in much the same way they attracted their first collectors. This desire to look is an important factor that connects the earliest viewers in the nineteenth century and their twenty-first century

Man in formal dress, 1870s. Studio of Stillfried & Andersen Co., Raimund von Stillfried, photographer. Hand-tinted albumen print, 23.5 × 19.2 cm (9¼ × 7½ in.). Collected by William S. Bigelow, 1880s. Gift of Mary Lothrop, 1927. PM 2003.1.2223.346 (96870001).

This subdued and dignified image of an older man in formal dress looks very much like a portrait that could have been produced for the sitter himself, rather than for sale as a tourist souvenir. Nevertheless, the image was available from the Stillfried studio as a regular commercial product.

successors. Yet this impulse need not be understood as voyeuristic; rather, it can be thought of as an aesthetic and intellectual desire to know and to engage in a continuing dynamic relationship between the photographs and their viewers. What are the implications of our desire to look as we continue to engage with these and other photographs of the past?

The Peabody Museum's collection of nineteenth-century photographs of Japan belongs to a body of images that once attracted tourists and other foreigners interested in acquiring images of "things Japanese," and unsurprisingly, many of them were of stereotypically "Japanese" subjects, such as geisha, samurai, temples, and cherry blossoms. By presenting these photographs today, do we perpetuate those stereotypes? Or are we able to use them to come to more nuanced understandings of both the past and the present?

The fact remains that contemporary viewers, too, are fascinated by this subject matter. Popular media and guidebooks produced both internationally and in Japan are lavishly illustrated with images of elegantly and exotically attired geisha (or more accurately, *maiko*, the young and photogenic apprentice geisha who visually conform to Western expectations for geisha) and other symbols of Japan's past. But in a contemporary twist, signs of modern and Western influence are no longer excised from the photographic frame. In fact, the new—skyscrapers, advanced technology, and other signs of (post)modernity— is often purposefully pictured (and edited in when necessary) as an ironic or astonishing contrast to the old, adding a layer of dissonance that updates but does not upend older stereotypes.

Together with the avalanche of other Japanese-produced imagery in the form of *manga* (comics) and *anime* (animation) that has made its way into the global visual economy, let alone the ubiquitous images of "cute" exemplified by Hello Kitty products, contemporary images of "things Japanese" provide a new generation of foreign consumers with ample visual material. Today, although there is no dearth of physical objects bearing these stereotypical images, photographic prints as such are no longer collected by tourists to Japan. Nearly every visitor carries his or her own camera or smartphone, and the resulting digital images have all but replaced any demand for printed photographs. These images circulate as physical photographs once did, but they travel instantaneously via the Internet and without the physical constraints and limitations of a material object. Despite their rapid dissemination, might these images lose staying power as compared to their predecessors, as they can all too easily be discarded, deleted, or replaced? Do they lose a sense of gravitas or preciousness

because they can be procured/shared/created by anyone with a camera phone? Or might they become even more valuable, more personal, than the printed photographs of the nineteenth century, which were purchased commodities as opposed to self-created images? Our new personal media constructions have altered what constitutes an "ideal" or "typical" visual representation—complicating the definition (or very existence) of such an image.

But photographs of Japan are by no means the only images preserved in the Peabody's and other institutions' archives. From the time of its invention, photography spread rapidly around the globe, first in the hands of Western and colonial observers of exotic places and cultural "others", but very quickly assimilated into local practices. The Japanese example is particularly interesting because the first photographers in the newly opened country were artists and entrepreneurs rather than direct colonial agents; their works were subsequently appropriated as cultural documentation by scientists who did not have the access to local cultures that they did in colonial contexts. Throughout sub-Saharan Africa, for example, the introduction of photography took a very different course, as it did throughout many of the colonized territories of the late nineteenth century. In this photographic record we see not only a "documentation" of people and places, but perhaps more significantly, the traces of the relationship between photographer and subject.

If an updated version of a photography of Japan—one created by tourists and other amateurs, as well as professionals in media, entertainment, other corporate capacities, and the arts—exists mainly in digital form now and for the foreseeable future, how then might one imagine a place for collections of early Japanese photographs such as the Peabody Museum's? Indeed, that collection is now largely accessible online, adding the museum's historical Japanese images to the cache of more recent and contemporary images residing digitally in institutional databases and on commercial websites, privately published blogs, and other social media.

One answer is to conduct examinations like the one I have tried to accomplish in this book: to think about photographs in the context of their creation and initial consumption, their subsequent reappropriation into the scientific record, and their continuing value as historical records, collective memories, and digital assets. Our desire to look can also be a desire to know, and combined with examination of other archival and historical documents and ethnographic studies, this desire can motivate us to think about how we use the past in the present, and how visual imagery captures and reflects both past

and present cultural realities. The availability of historic images in public or private archives allows them to move outside their original context and to be reappropriated in different time periods for different purposes. This intellectual engagement keeps the photographs alive and provides a growing body of reimagined images that continue to delight, amaze, inspire, and teach us about ourselves and others.

ACKNOWLEDGMENTS

☺

I owe a huge debt of gratitude to the many mentors, colleagues, friends, and family members who advised and supported me throughout the process of writing this book. The project came into being thanks to the generosity of Rubie Watson, former director of the Peabody Museum, who first invited me to examine the Bigelow collection and encouraged me to curate an exhibition and write this book. I cannot thank her enough for her friendship and gracious support of my work over the ensuing years. My sincere thanks also to Professor Watson's successors at the Peabody: William Fash, under whose direction my exhibition was mounted, and current director Jeffrey Quilter. Their continued interest has allowed this project to come to completion.

The entire staff of the museum has my deepest gratitude, but the nature of my research meant that I relied particularly heavily on access to the museum's archives and collections, and so I am especially grateful to India Spartz, Patricia Kervick, and Susan Haskell for so generously sharing their time and expertise. Thanks are due also to Janet Steins, whose knowledge of the Tozzer Library collections proved invaluable to the project. John William Day and Maggie M. Cao provided valuable early research and editorial assistance. My research was further advanced by discussions with Ilisa Barbash, Theodore C. Bestor, Victoria Lyon Bestor, Deborah Martin Kao, Theodore Gilman, Helen Hardacre, Robert Hellyer, Michelle Lamunière, Andrew Maske, and Castle McLaughlin.

I would like to make a special acknowledgment to Elizabeth Edwards for generously writing the foreword to this book, for her critical reading of a draft of the manuscript, and for her seminal scholarship in the anthropology and history of photography, which continues to inform my thinking to this day. I was privileged to study with her at the University of Oxford, where she taught my cohorts and me the value of "fieldwork in the archives." Luke Gartlan's careful reading of my manuscript was also enormously helpful. His stellar scholarship and our

many lively discussions over the years have been essential to my thinking about Japanese photography. I have also benefited greatly from Melissa Banta's pioneering work on the Bigelow collection, as well as her subsequent scholarship, exhibitions, and our many fascinating discussions about early photography.

Joan Kathryn O'Donnell's patience in overseeing the editorial and production process was only surpassed by her astute and insightful reading of manuscript drafts. Donna Dickerson organized and prepared illustrations for publication and shepherded the book through production with remarkably good cheer and meticulous attention to detail. Peabody Museum Press interns Lisa Hoffman and Olivia Tyson provided valuable research assistance in the museum's photographic archives during a critical phase of preparation. I am also most grateful to Evelyn Rosenthal for her thorough and expert editing of the text and to David Skolkin for his elegant book design.

The Reischauer Institute of Japanese Studies first brought me to Harvard to undertake a postdoctoral fellowship at the university, and its continued support over the years has been unfailing. The Institute not only provided generous financial assistance for my early research and the mounting of the exhibition, but also supported the publication of this book.

Finally, I thank my parents, Franklin and Enid Odo; my parents-in-law, Alan and Lorna Keat; and my wife, Jane Keat, for their unfaltering love and support in all my endeavors.

NOTES

i. Elizabeth Edwards and Sigrid Lien, eds., *Uncertain Images: Museums and the Work of Photographs* (Farnham, UK: Ashgate, 2014).

ii. Elizabeth Edwards and Christopher Morton, eds., *Photographs, Museums, Collections: Between Art and Information* (London: Bloomsbury, 2015).

iii. Christopher Pinney, "Things Happen: Or, From Which Moment Does That Object Come?" In *Materiality*, ed. Daniel Miller (Durham, NC: Duke University Press, 2005), p. 264.

iv. Franco Moretti, *Graphs, Maps, Trees: Abstract Models for Literary History* (London: Verso Books, 2005), p. 4.

v. Edwards and Morton, *Photographs, Museums, Collections*.

1. The exhibition, based on the museum's collections, was titled *"A Good Type": Tourism and Science in Early Japanese Photographs*, and was co-curated with Ilisa Barbash, the museum's curator of visual anthropology, and exhibited at the Peabody Museum in 2007–8. Research for the exhibition has been expanded and incorporated into this volume.

2. Stillfried's surname is variously spelled Rathenitz, Ratenicz, and Rattonitz. The Rathenitz spelling is most commonly used in the literature about his work.

3. My thanks are due to Patricia Kervick, Peabody Museum archivist, whose expertise in handwriting recognition helped to identify Bigelow as the author of the caption in question.

4. For a full discussion of this album, see Gartlan 2005.

5. An even more troubling subtext here is the equation of Japanese women in general with geisha.

6. Harvard University, 1926–27.

7. The albumen printing process—in which a photographic negative is placed in contact with a paper substrate coated with an emulsion of egg white and salt and then exposed to light—was introduced by Louis Blanquart-Evrard to the French Academy

of Sciences in 1850. By 1855 it had become the dominant positive photographic printing process, and it remained so until at least 1890. A good discussion of the history, varieties, and identification of albumen prints is found in Stulik and Kaplan 2013.

8. The Peabody Museum owns additional Japanese photographs that were produced and collected in later periods, particularly after World War II; those images are not considered here.

9. Beginning in the 1630s, the Tokugawa shogunate severely restricted trade with foreign countries—for example, allowing Dutch traders (the sole Europeans with this right) to operate limited concessions in Japan, with their presence restricted to Dejima, an artificial island in Nagasaki Bay in the south of the country.

10. For a richly illustrated and fascinating discussion of this issue, see Guth 2004.

11. Beato is also known by his Anglicized name, Felix.

12. Morse was a proponent of Darwin's theories and had a foundational influence on the fields of zoology, archaeology, biology, and social anthropology in Japan. Early in his career, Morse worked with Louis Agassiz at Harvard's Museum of Comparative Zoology, and he later directed the Peabody Academy of Sciences (now the Peabody Essex Museum) in Salem, Massachusetts.

13. In addition to the 2007–8 exhibition *"A Good Type"* (see note 1, above), the collection was featured in *A Timely Encounter: Nineteenth-Century Photographs of Japan,* curated by Melissa Banta and Susan Taylor in 1988, which included material from both the Peabody and the Wellesley College Museum of Art. It was the first public exhibition of photographs from the Bigelow collection. See Banta and Taylor 1988.

14. Some of Bigelow's Japanese photographs went to the William Morris Hunt Library at the Museum of Fine Arts after his death in 1926 and were eventually (in 2009 and 2010) transferred to the museum's collection. The prints in the MFA's collection are mainly Beato albumen prints dating to the 1860s.

15. Information on Hiller is from Katz 1999.

16. The inclusion of these photos in the larger Japanese collections is further complicated by the question of whether or not the images can even be considered to be of Japanese subjects, since the Ainu were—and are—generally considered to be a separate "race" from the Japanese.

17. See, for example, Sekula 1986 and Schwartz 1995.

18. Sladen 1904, p. 325.

19. For more on Beato, see Bennett 2006, pp. 86–97.

20. See Gartlan 2004, pp. 40–65.

21. Kinoshita 2003, pp. 16–35.

22. Guth 2004, p. 54.

23. Hockley 2008.

24. Ibid. Kozaburo Tamamura (1856–19?) was a very successful Yokohama photographer, known for his souvenir albums, who sold to individual clients and also received prestigious (and lucrative) commissions, including one in 1896 to provide 151,500 large-format photographs and 254,000 small-format photographs for the Boston publisher J. B. Millet. These photographs were used as illustrations in 37,750 copies of *Captain Francis Brinkley's Japan: Described and Illustrated by the Japanese*; see Bethel 1991, p. 9. Tamamura's advertising touted his use of high-quality developing chemicals that ensured long-lasting images.

25. Dower 1981.

26. Hight 2002, pp. 126–28.

27. Murakata 1971, p. 371.

28. Banta 1988, p. 15. Other Bostonians inspired by Morse included Isabella Stewart Gardner, Percival Lowell, Henry Adams, and John LaFarge.

29. Edwards 1990, p. 240.

30. For more, see Gould 1981 and Stocking 1987.

31. Edwards 1990, p. 240.

32. After commissioning the 1850 daguerreotypes, Agassiz continued to conduct research using scientific photographs. What I am here calling a "collection" was created not as a single group but as part of multiple projects over time. However, the photographs can be grouped together because of their common origins as evidence for Agassiz's theories.

33. Rogers 2006, p. 41.

34. Ibid., 45.

35. Lamprey 1869, pp. 84–85.

36. This was not limited to British colonies, however, and forms of anthropometric type photography were produced throughout the colonial world, including French, Dutch, and German territories.

37. Edwards 2001, pp. 138–40.

38. There are immense photographic archives of Ainu, Okinawan, Korean, Chinese, Melanesian, and other subjects made during Japanese colonial rule, currently held by such institutions as the University of Tokyo, the National Diet Library, and the Tokyo National Museum.

39. Robertson 2002, p. 192.

40. For more on Baelz in Japan, see Wakabayashi 2001.

41. For more on Potteau's project, see Sheptytsky-Zall 2009.

42. See Edwards 1990 for a detailed account of Dammann and his photography.

43. Capron's widow, Margaret, sold his collection of Japanese art to the Smithsonian Institution in 1888.

44. Morris-Suzuki 1998, p. 25.

45. Siddle 1996, p. 30. For examples and an overview of Ainu-e, see Sasaki 1999, pp. 79–85.

46. For details on collections of Ainu materials in Europe and North America, see essays in Fitzhugh and Dubreuil 1999.

47. Morse 1886, vii–viii.

48. Ibid.

49. Clifford 1986, p. 112.

50. Herzfeld 2002, p. 901.

51. The terms of these treaties, which were so unfavorable to the Japanese, were negotiated under threat of military force. They lasted until the Japanese demonstrated their military might in the first Sino-Japanese War.

52. This foreshadowed similar reactions in Western countries during the trade frictions of the 1980s, when critics attempted to locate postwar Japanese economic success in Japanese culture.

53. Chamberlain 1891, p. 13.

54. William Sturgis Bigelow invited Okakura to work at Boston's Museum of Fine Arts in 1904, where he was to become the first head of its Asian Art Division in 1910.

55. An exception to this are the photographs of Western-style buildings catering to foreigners, such as social clubs, hotels, and embassies, which lined the Bund (commercial thoroughfare) in treaty ports such as Yokohama, Kobe, and Nagasaki. It is exceedingly rare to find images of Japanese government and other modern, Western-style buildings included in tourist collections.

56. Advertisement in *Life (1883–1936)* 26, no. 653 (July 4, 1895): 15.

57. Odo 2000.

58. Gartlan 2006, p. 239.

59. For a discussion of "portrait" types, an alternative term for native types, see Edwards 1990, pp. 237, 241–42, 245.

60. Gartlan 2006, p. 239 and note 1.

61. Ibid., p. 240.

62. Ibid., pp. 243–47.

63. I have examined volumes of Japanese costume illustrations at the Wereldmuseum Rotterdam and the Museum Volkenkunde, Leiden, and their subject matter follows the same thematic patterns as Japanese souvenir photography, as well as broader native type photography.

64. For examples of Japanese type cartes-de-visite, see Odo 2008.

65. See, for example, the collection at the Dutch Royal Archives at The Hague.

66. Gartlan 2006, pp. 251–56.

REFERENCES

Banta, Melissa. 1988. "Life of a Photograph: Nineteenth-Century Photographs of Japan from the Peabody Museum and Wellesley College Museum." In Banta and Taylor 1988, pp. 11–21.

Banta, Melissa, and Susan Taylor, eds. 1988. *A Timely Encounter: Nineteenth-Century Photographs of Japan*. Cambridge: Peabody Museum Press.

Bennett, Terry. 2006. *Photography in Japan, 1853–1912*. Rutland, VT: Tuttle Publishing.

Bethel, Denise. 1991. "The J. B. Millet Company's Japan: Described and Illustrated by the Japanese, An Initial Investigation." *Image* 34, nos. 1–2 (Spring–Summer): 2–15.

Chamberlain, Basil Hall. 1891. *A Handbook for Travellers in Japan*. 3rd ed. London: John Murray.

Clifford, James. 1986. "On Ethnographic Allegory." In *Writing Culture: The Poetics and Politics of Ethnography*. Edited by James Clifford and George E. Marcus, pp. 98–121. Berkeley: University of California Press.

Dobson, Sebastian, Anne Nishimura Morse, and Frederic A. Sharf. 2004. *Art & Artifice: Japanese Photographs of the Meiji Era*. Boston: MFA Publications.

Dower, John W. 1981. "Ways of Seeing, Ways of Remembering: The Photography of Prewar Japan." In Japan Photographers' Association, *A Century of Japanese Photography*. New York: Pantheon.

Edwards, Elizabeth. 1990. "The Image as Anthropological Document. Photographic 'Types': The Pursuit of Method." *Visual Anthropology* 3 (2–3): 235–58.

———. 1992. *Anthropology and Photography, 1860–1920*. New Haven: Yale University Press, in association with The Royal Anthropological Institute, London.

———. 2001. *Raw Histories: Photographs, Anthropology and Museums*. Oxford: Berg.

Fitzhugh, William W., and Chisato O. Dubreuil, eds. 1999. *Ainu: Spirit of a Northern People*. Washington, DC: Arctic Studies Center, National Museum of Natural History, Smithsonian Institution in association with University of Washington Press.

Fraser, Karen M. 2011. *Photography and Japan*. London: Reaktion Books.

Fukuoka, Maki. 2011. "Early Photographic Business in Asakusa, Japan." *History of Photography* 35 (4): 355–73.

Gartlan, Luke. 2004. "Changing Views: The Early Topographical Photographs of Stillfried and Company." In Rousmaniere and Hirayama 2004, pp. 40–65.

———. 2005. "Views and Costumes of Japan: A Photograph Album by Baron Raimund von Stillfried-Ratenicz." *La Trobe Journal* 76 (Spring): 4–26.

———. 2006. "Types or Costumes? Reframing Early Yokohama Photography." *Visual Resources* 22:239–63.

———, ed. 2009. "Photography in Nineteenth-Century Japan." Special issue, *History of Photography* 33 (2).

———. 2012. "'Bronzed and Muscular Bodies': Jinrikishas, Tattooed Bodies, and Yokohama Photography." In *Transculturation in British Art, 1770–1930*. Edited by Julie F. Codell, pp. 93–110. London: Ashgate.

Gould, Stephen Jay. 1981. *The Mismeasure of Man*. New York: W. W. Norton & Co.

Guth, Christine. 2004. *Longfellow's Tattoos*. Seattle: University of Washington Press.

Herzfeld, Michael. 2002. "The Absent Presence: Discourses of Crypto-Colonialism." *South Atlantic Quarterly* 101 (4): 901.

Hight, Eleanor M. 2002. "Traveling with Beato's Beauties." In *Colonialist Photography: Imag(in)ing Race and Place*. Edited by Eleanor M. Hight and Gary D. Sampson, pp. 126–28. London: Routledge.

———. 2011. *Capturing Japan in Nineteenth-Century New England Photography Collections*. Farnham, UK: Ashgate.

Hockley, Allen. 2006. "Expectation and Authenticity in Meiji Tourist Photography." In *Challenging Past and Present: The Metamorphosis of Nineteenth-Century Japanese Art*. Edited by Ellen P. Conant, pp. 114–31. Honolulu: University of Hawaii Press.

———. 2008. "Globetrotters' Japan: Places, Foreigners on the Tourist Circuit in Meiji Japan." http://ocw.mit.edu/ans7870/21f/21f.027/gt_japan_places/index.html.

Katz, Adria H. 1999. "An Enthusiastic Quest: Hiram Hiller and Jenichiro Oyabe in Hokkaido, 1901." In Fitzhugh and Dubreuil 1999, pp. 162–67.

Kinoshita, Naoyuki. 2003. "The Early Years of Japanese Photography." In Tucker et al. 2003, pp. 16–35.

Lamprey, John. 1869. "On a Method of Measuring the Human Form, for the Use of Students in Ethnology." *Journal of the Ethnological Society*, n.s., 1:84–85.

Life (1883–1936). 1895. 26, no. 653 (July 4): 15 (advertisement).

MIT Visualizing Cultures. http://ocw.mit.edu/ans7870/21f/21f.027/home/index.html.

Morris-Suzuki, Tessa. 1998. *Re-inventing Japan: Time, Space, Nation, Japan in the Modern World*. Armonk, NY: M. E. Sharpe.

Morse, Edward S. 1886. *Japanese Homes and Their Surroundings*. Boston: Ticknor and Co.

Murakata, Akiko. 1971. "Selected Letters of Dr. William Sturgis Bigelow." Ph.D. diss., The George Washington University.

Odo, David. 2000. "Anthropological Boundaries and Photographic Frontiers: J. H. Green's Visual Language of Salvage." In *Burma: Frontier Photographs, 1918–1935*. Edited by Elizabeth Dell, pp. 41–49. London: Merrell, in association with the Green Centre for Non-Western Art.

———. 2008. *Unknown Japan: Reconsidering 19th-Century Photographs*. Rijksmuseum Studies in Photography 4. Amsterdam: Rijksmuseum.

Robertson, Jennifer. 2002. "Blood Talks: Eugenics, Modernity and the Creation of New Japanese." *History and Anthropology* 13 (3): 191–216.

Rogers, Molly. 2006. "The Slave Daguerreotypes of the Peabody Museum: Scientific Meaning and Utility." *History of Photography* 30 (1): 38–54.

Rousmaniere, Nicole Coolidge, and Mikiko Hirayama, eds. 2004. *Reflecting Truth: Japanese Photography in the Nineteenth Century*. Amsterdam: Hotei Publishing.

Sasaki, Toshikazu. 1999. "Ainu-e: A Historical Review." In Fitzhugh and Dubreuil 1999, pp. 79–85.

Schwartz, Joan M. 1995. "'We Make Our Tools and Our Tools Make Us': Lessons from Photographs for the Practice, Politics, and Poetics of Diplomatics." *Archivaria* 40: 40–74.

Sekula, Allan. 1986. "The Body and the Archive." *October* 39 (Winter): 3–64.

Sheptytsky-Zall, Juli. 2009. "Collection Anthropologique du Muséum de Paris: Ethnographic Portraits by Jacques-Philippe Potteau." Master's thesis, Ryerson University.

Siddle, Richard. 1996. *Race, Resistance, and the Ainu of Japan*. London: Routledge.

Sladen, Douglas. 1904. *Queer Things About Japan*. London: Anthony Treherne and Co., Ltd.

Stocking, George, Jr. 1987. *Victorian Anthropology*. New York: Free Press.

Stulik, Dusan C., and Art Kaplan, 2013. *Albumen. The Atlas of Analytic Signatures of Photographic Processes*. Los Angeles: The Getty Conservation Institute.

Tucker, Anne, Dana Friis-Hansen, Kaneko Ryuichi, and Takeba Joe, eds. 2003. *The History of Japanese Photography*. New Haven: Yale University Press in association with the Museum of Fine Arts, Houston.

Wakabayashi, Misako, ed. 2001. *Berutsu Nihon bunka ronshū*. Tokyo: Tokai University Press.

INDEX

Composed in Granjon, Berthold Akzidenz Grotesk, and Johann Sparkling.
Printed on Premium Garda Silk 100 lb.
Bound in Brillianta 4197 and Offset White Endleaf 80 lb.

Editorial direction by Joan Kathryn O'Donnell
Editing by Evelyn Rosenthal
Cover and book design by David Skolkin
Typesetting by Angela Taorimina
Production management by Donna M. Dickerson
Digital prepress by Friesens
Printed and bound in Canada by Friesens